Wicked
DETROIT

Wicked
DETROIT

MICKEY LYONS

THE
History
PRESS

Published by The History Press
Charleston, SC
www.historypress.net

Copyright © 2018 by Michelle Lyons
All rights reserved

First published 2018

Manufactured in the United States

ISBN 9781467140027

Library of Congress Control Number:

To my amazing sister Jen,
without whom this book would not have happened.

CONTENTS

Preface

WHAT THIS BOOK IS, AND WHAT IT IS NOT

*D*etroit's history of wickedness is lengthy and, frankly, often deeply disturbing. Our legacy of racism and violence stretches back to the city's founding by French settlers. The atrocities committed against the Native American and African American people in our city's history are numerous.

This book is not about those atrocities. Although they deserve deep study and have been the subject of several remarkable academic works, this little book is an attempt, not to make light of our troubled past, but to offer some amusing anecdotes for the reader interested in a broad view of the characters who made Detroit what it is. I have done my best to present these characters as kindly as possible, knowing that ours is a more enlightened yet still flawed perspective. The men in this book may have been monsters in some ways, but they also were often funny, quixotic and, above all, entirely human.

ACKNOWLEDGEMENTS

When I set out to write this book, I had no idea what I was getting into. That's probably a good thing. I owe thanks to many people and groups, including but not at all limited to:

The Burton Historical Collection at the Detroit Public Library. The Burton is an invaluable research for any scholar of Detroit history.

The Detroit research community and its associated internet forums, including Detroit Researchers, Detroit Drunken Historical Society and the Detroit Yes forum. It's remarkable how smart we all are when we put our heads together.

The anonymous person or people tasked with digitizing the *Detroit Free Press* archives. Bless you, nameless intern.

The Detroit Metro Convention and Visitors Bureau, whose archives I had the pleasure to catalogue, which led me down some important research paths.

Jason Marker, for the idea of investigating Detroit's charlatans and for the podcast that hasn't happened yet. I'm still holding out hope.

Konrad Maziarz, former Hamtramck librarian with a heart, who found articles for me and worked his creative magic at the circulation desk.

My fantastic editor John Rodrigue from The History Press. Writing is always easier when you can share Dickens quips and bad puns.

Laila Khan, Caitlin McAteer, Katie Palonis, Dan Archer and Colleen Robar, for listening to my historical yammering, talking over beers, beta reading chapters, going on cemetery adventures and mostly for being patient with me while I wrote this book.

And Jen Lyons, who read every word and offered astute advice and a keen editing eye. She also kept me fed on more than one occasion.

INTRODUCTION

*O*n July 24, 2001, a vast multitude gathered to witness a historic event. At the foot of Woodward Avenue (named for one of the greatest city planners of all time), the jubilant crowd watched as historical reenactors dressed as the legendary Antoine de la Mothe, Sieur de Cadillac, and others landed their birch bark canoes and stepped foot on Detroit soil. Speeches were made. Banners were waved. The joyful citizens of Detroit celebrated the heroic founders and forefathers of our city. Three hundred years of triumphant progress under the leadership of great men had led us to this shining moment.

Sort of. In some ways, Detroit has achieved what it has in spite of, rather than because of, three centuries of the likes of Woodward and Cadillac. We are a city founded on the greed of one man, and things went impressively downhill from there. Detroit has seen more than its share of tragedy and trauma. Much of that was caused by mismanagement and corruption by the very figures we selected to lead us.

Still, I can't help but love Detroit's shady past and the scoundrels, cads and frauds that shaped it. I like to imagine Augustus Not His Real Name Woodward flapping his way down the dusty streets of burned-out Detroit, his eyes gazing into a distant future filled with grand boulevards and shining palaces while he treks through streets filled with mud and offal. I'd like to pop into Billy Boushaw's ramshackle tavern on Atwater and quaff a Stroh's while we talk swimming holes and argue politics. I wouldn't mind swapping a story or two about the old country with Paddy McGraw—in

the company of criminals and hookers and factory workers—especially if he promised to play me a tune on his fiddle. And if jovial William Cotter Maybury offered me a ride in his swanky new Ford, I'd hop in without a second thought. With the exception of Charles Bowles (there's just nothing redeemable about that man), each of the characters in these pages charmed me in one way or another. They're petulant and selfish and outrageous charlatans, the lot of them, but they're our charlatans, darn it. We made them, and they made us.

Detroit's history is dirty and rough and filled with reprobates, and I love it. The story of a city clearly emerges more through its missteps than its triumphs. Heroes are boring. Give me a larger-than-life cad any day over a sanctimonious preacher. There's a reason that one of our favorite figures in Detroit is Le Nain Rouge, the diabolical imp of indeterminate origin. We love the dark side because we've experienced so much of it here. We're all a little wicked inside, right?

ANTOINE CADILLAC

Detroit's Founding Scoundrel

otor City. City of Champions. Motown. Paris of the Midwest. Murder City. Arsenal of Democracy. A city as grand as Detroit in its heyday, with its storied three-hundred-year history, must certainly have an equally epic story of origin, with the dashing Antoine Laumet de la Mothe, Sieur de Cadillac, as its heroic founder. Braving the wilds of winter and the perils of war, the great Cadillac, noble son of Burgundy, planted the flag of France on the banks of a narrow strait between two lakes on July 24, 1701. For years after, Cadillac guided the burgeoning colony with a firm but benevolent hand and defended its citizens against privation and predation by Jesuits, Iroquois and greedy *voyageurs*.

At least, that's the PR version of Detroit's founder. As it turns out, though, almost nothing we know of the city's founder is true—even down to his very name and origin. Antoine Laumet was born on March 5, 1658, in St. Nicolas-de-la-Grave, a provincial town in southern France, halfway between the Atlantic Ocean and the Mediterranean Sea. Situated at the confluence of the Tarn and Garonne Rivers, the sleepy little hamlet offered very little in the way of grandeur—so Antoine Laumet decided to make some up. Antoine's father, he later declared, was Jean de la Mothe, Sieur de Cadillac, Launay et Le Moutet, counselor to the parliament in Toulouse—his mother, Jeanne de Malenfant. In fact, his father was a simple small-town clerk-bailiff, and Antoine grew up in a middle-class home. So far as his later letters indicate, he received a decent education, with Latin and military history being among the subjects he studied.

As Antoine Laumet, he entered the military—probably. It has been suggested that he forged or borrowed the military record of an older brother. Regardless, by the time he set sail for the New World in 1683, the young man had dubbed himself Antoine de la Mothe, Sieur (Squire) de Cadillac. His family crest and noble name were likely borrowed from a neighbor in southern France, Baron Sylvester of Esparbes de Lussan, lord of Lamothe-Bardigues. Landing in Port Royal, a small peninsula in present-day Nova Scotia just across the Bay of Fundy from Mount Desert Island, Cadillac (as we will call him henceforth, for the sake of convenience) soon fell into the company and employ of Francois Guyon, a privateer plying the seas all along the East Coast, from Maine to the Carolinas. The young Cadillac ingratiated himself with his employer, and on June 25, 1687, he married Guyon's niece, seventeen-year-old Marie-Therese Guyon.

Just two days after his marriage, Cadillac, then twenty-nine, applied for land grants from the French Crown and, no doubt thanks to his legendary arts of persuasion, received the gift of land in what is now northern Nova Scotia at Port Royal. Soon after, Cadillac wheedled his way aboard an excursion on the battleship *Embuscade* (Ambush) to explore and map the coast, noting English forts and strategic holdings. Gale winds and unfavorable seas, though, forced the ship to divert and make for France, where Cadillac immediately took advantage of the opportunity to ingratiate himself at court. There he convinced various ministers and hangers-on that he was intimately familiar with the British American coast and was promptly granted a lieutenancy in the naval forces.

Back on the coasts of North America, his young wife, Marie-Therese, was not so lucky. She had endured an attack on the Lamothe estates in Acadia and attempted to flee to France. Unfortunately, her ship was attacked by a British privateer outside of Boston, and the bulk of the Cadillac fortune, such as it was to this point, was lost.

Once again nearly penniless and landless, Cadillac sprang into action. From 1691 to 1693, he busied himself with producing a map of the North American coast; it is unclear exactly how much of that coastline he personally surveyed and how much he simply manufactured from his vivid imagination. If contemporary maps are any indication, it mattered little. He presented them at court and was duly recognized as a master of military mapmaking; on his return to Quebec, Cadillac moved quickly through the ranks, collecting money and promotions as he went. In 1694, his ally Governor Frontenac promoted him to commander of all French forts in the northern territories, including its most strategic possession, Fort Michilimackinac.

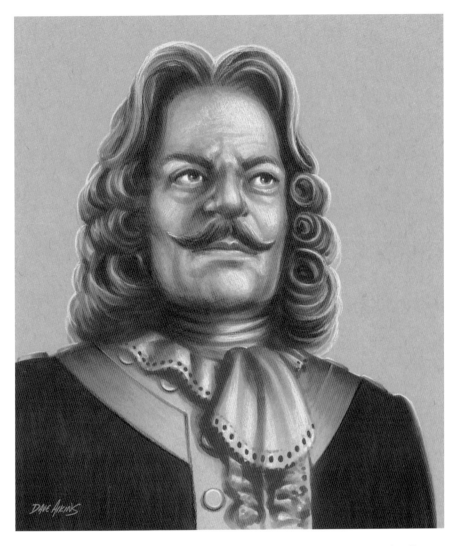

Artist's rendering of Antoine Cadillac, based on descriptions by his contemporaries. *By David Aikens, author's collection.*

Demonstrating a pattern that would become all too common, though, Cadillac tarried at Quebec and Montreal for several months, then set out on a leisurely expedition to study his new domain.

Another common Cadillac trademark was his remarkable ability to turn a profit, despite the strictures imposed on government agents in charge of trade in New France. Although rumors of his misconduct had begun circulating by the time he sailed for France to hand over his maps of the

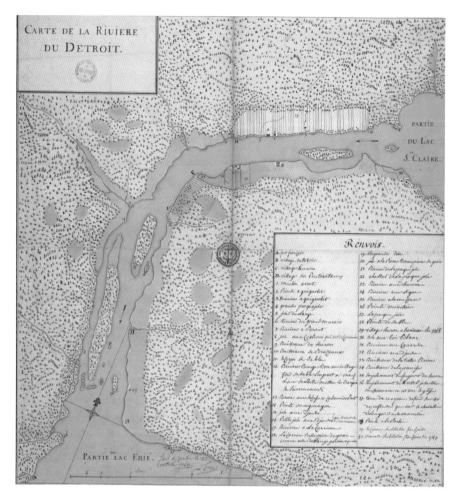

Map of Detroit River, 1749. *Library and Archives of Canada.*

East Coast, he'd managed to reassure his patron, Count Pontchartrain, sufficiently that Pontchartrain's ally Frontenac continued to support Cadillac's swift promotions in the New World. By 1696, however, the allegations had become more heated. Cadillac's rancorous relationship with the Jesuit priests stationed at Michilimackinac prompted a flurry of angry letters to the provincial governors.

Simply put, Cadillac's beef with the Jesuits can be boiled down to two factors: money and booze. Since the earliest days of French exploration in the Great Lakes, the court—convinced by the Jesuit missionaries who had been there since the 1630s—strictly limited the amount of brandy that

could be traded to individuals or tribes in the Great Lakes. Constitutionally unaccustomed to the potency of the brandy and rum now available through trade, the Ottawa, Miami, Potawatomi and other tribes that traded with the French soon came to prefer the wet stuff as payment for the beaver pelts and deerskins they brought to the fort. Aside from the obvious effects brought by drunkenness, brandy proved a portable, consistent and stable currency in the backwoods and was traded among the tribes and the *coureurs de bois* with far more frequency than was reported.

Cadillac was more than happy to aid in the circulation of brandy throughout the region, regardless of decrees and quotas imposed by Montreal. It certainly helped Cadillac that, with demand and a limit to the official supply, he could charge up to twenty-five French pounds for a pot of brandy that would fetch only three pounds in Montreal.

The Jesuits, however, knew firsthand the liquor trade's detrimental effect on the social and spiritual constitution of the First Nations tribes. Complaining that the tribesmen who came to the fort to trade were neglecting to purchase food, tools and other necessities to prepare for the harsh winters in favor of accepting only brandy as payment, the Jesuits began a series of strident letters to their superiors in the order begging for sanctions against Cadillac's excessive trade. Another concern, they warned, was that the French could not compete with the lower prices and greater abundancy of liquor offered by the English trading in the area at the time. With tensions in the area between the Iroquois to the east and the Ottawa, Miami and Huron's shifting alliances in the north and west, a catastrophic uprising was never far off.

At first, Cadillac, ever loquacious in his frequent letters to Quebec and Paris, brushed off the Jesuit's complaints. On getting along with the Jesuits, he said, "I have found only three ways of succeeding in that. The first is to let them do as they like; the second, to do everything they wish; the third, to say nothing about what they do."[1] Despite this affable chaffing, though, Cadillac's demands on the priests at his missions were intense. Claiming that the Jesuits "prefer certain hucksters, who have no weight with our allies" the Native American tribes, Cadillac essentially circumvented the Jesuits' demands and those of the government by using government boats and soldiers to smuggle his contraband all over the northwestern area. In fact, within three years of his penniless arrival at Michilimackinac, Cadillac had sent 27,600 livres to France for safekeeping. Considering that the average late seventeenth-century settler in New France made an annual income of 75 livres, Cadillac's scheme was highly profitable. By the time he reached Detroit, he had perfected this model.[2]

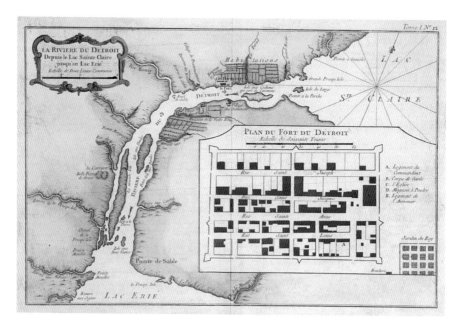

Fort de Detroit, 1749. *Library and Archives of Canada.*

His unorthodox methods did not go unnoticed. In 1796, while Cadillac was stationed at Michilimackinac, his wife, Marie-Therese, oversaw the departure of two boats from Montreal filled with trade goods destined for the fort, valued at 3,000 pounds. The two men in charge of the shipment, Louis Durand and Joseph Moreau, were authorized to bring a small amount of gunpowder and brandy for trade along the journey. In addition to the declared goods, Marie-Therese loaded the boats with as much contraband as they could carry for her husband to privately sell. Tucked discreetly among the official and not-so-official goods were a few items here and there that Durand and Moreau added for their own profit.

Before the boats departed Montreal, however, they were inspected by the fort's commissary, and the illegal goods were discovered. The contraband was seized and catalogued, and Durand and Moreau were ordered to sign promissory notes for the value of the goods. Durand and Moreau were then permitted to continue on to Michilimackinac, where Cadillac promptly seized the goods as well as the promissory notes. He tossed the pair into jail, despite the fact that they had merely been following his private orders, and took advantage of their imprisonment to sack their home and small storehouse, taking every last item—including bills of credit

the two had amassed totaling 3,100 pounds, to which Cadillac then signed his own name. He had Durand arrested again not long after for killing a dog belonging to one of the Ottawa people staying at the fort. Moreau, meanwhile, had no choice but to scrounge up what he could and set out to trade what little he had in order to start repayment on the seized goods.

Durand and Moreau took their case to court in Quebec. Cadillac fought it bitterly and at length, even going so far as to insist that the case should be heard in France. When the intendant of New France, Jean Bochart de Champigny, ruled that this was an unfair expense on the beggared Durand and Moreau, the case remained in Canada. Nevertheless, the case dragged on for over six months due to Cadillac's ever-present obfuscations and objections. Durand, utterly penniless by now, was forced to settle his suit and accept a tiny fraction of what was taken from him. Moreau persisted, but after his application for credit based on an initial ruling was denied by Cadillac's ally Frontenac, he was left with little option. To add insult to injury, Moreau had taken work on a fishing boat in Quebec in order to sustain himself; Frontenac had him arrested at the docks as he was preparing to set off, charging him with attempting to travel without government permission. Eventually, Moreau too settled for far less than was owed to him: Champigny ordered Cadillac to pay Moreau 3,400 pounds. Cadillac drew out the case even longer, dallying about finishing the paperwork, until Moreau settled for half of that amount. To top off his stinginess, Cadillac paid the fine in local (rather than continental French) currency, which meant that Moreau received only 400 pounds in the end, a little more than 10 percent of the original settlement.[3]

Cadillac's tenure at Michilimackinac continued in this vein. At every opportunity, he squeezed any penny he could from whoever he could, whether they were Jesuits, settlers, traders or tribe members. His technique of flattery and sheer bullheaded persistence in the face of opposition made him few friends in the colonies. And while it did gain him attention in the French Court, Cadillac's reputation was never that of an honest, hardworking pioneer; rather, although he strong-armed and cheated his counterparts in the colonies, his patrons and supervisors in France often preferred to let him do what he wanted rather than have to deal with his insufferable letters and outrageous claims of victimhood. They were content to keep him in the New World and out of their hair.

May 1696 dealt Cadillac and his schemes a hefty blow, however. Faced with a massive surplus of beaver skins and a decrease in the demand for them in Europe, the king declared a moratorium on licenses to trade in

beaver in the colonies. The outpost at Michilimackinac was ordered shut down, effective immediately. Cadillac, incensed at his loss of position—and, more importantly, his loss of income—raced off to France to argue his case. With the recommendation of his old ally Frontenac in hand, Cadillac was promoted to lieutenant commander on arrival in Paris.

Taking advantage of his connections and his time at court, Cadillac presented a scheme for a new outpost in the New World. At a narrow strait between two sweet-water lakes, he declared, sat the ideal spot to control trade and simultaneously defend the Northwest against the imminent threat of conquest by the English and their Iroquois allies. With his trademark hyperbole, Cadillac declared the site a veritable paradise, a pastoral Eden untouched by human hands. Despite the fact that it's possible he had never visited the spot—and confirmed reports from Jesuits and voyageurs who had been visiting the area for decades that the climate and terrain were problematic—Cadillac described le détroit du Lac Érié as such:

> *The banks are so many vast meadows where the freshness of these beautiful streams keep the grass always green. These same meadows are fringed with long and broad avenues of fruit trees which have never felt the careful hand of the watchful gardener; and fruit trees, young and old, droop under the weight and multitude of their fruit, and bend their branches toward the fertile soil which has produced them....Under these vast avenues you may see assembling in hundreds the shy stag and the timid hind with the bounding roebuck, to pick up eagerly the apples and plums with which the ground is paved....The golden pheasant, the quail, the partridge, the woodcock, the teeming turtle-dove, swarm in the woods and cover the open country intersected and broken by groves of full-grown forest trees which form a charming prospect which of itself might sweeten the melancholy tedium of solitude.[4]*

Among Cadillac's other claims for the idyllic new site, he stated that a canal already existed between Lake Erie and Lake Ontario; that a profitable silk factory could be established without delay; that the colony could easily produce wines to rival the best in Burgundy; that the area boasted native citrus similar to oranges, but whose fruit was an immediate and effective cure for snakebite; and that thousands of Huron, Miami and Ottawa were ready to pull up stakes from their settlements at Mackinac and move to the southern locale.

Not everyone at court was convinced. Cadillac's unfavorable reputation as both a commander and a trader made him plenty of enemies. After

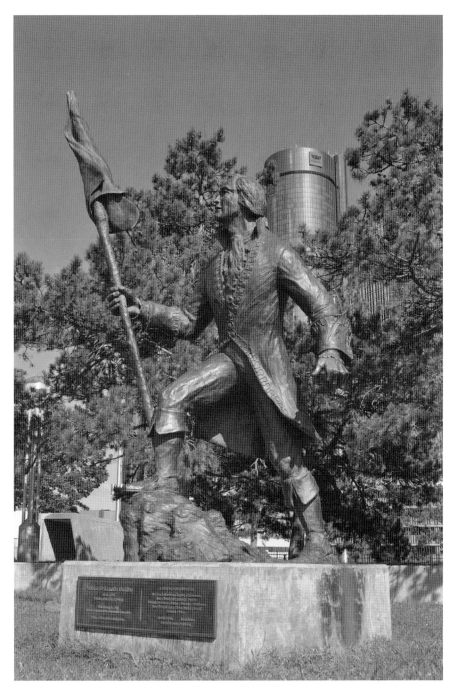

A statue representing Cadillac's landing on July 24, 1701, stands downtown near Hart Plaza. *Photo by the author.*

several treks back and forth across the Atlantic, though, Cadillac talked his way into a commission to establish a fort at Detroit. Several letters from the time indicate that Cadillac was granted permission simply to remove his objectionable presence from court.

On June 5, 1701, Cadillac departed from Montreal with twenty-five birch bark canoes, stocked with tools and supplies, alongside one hundred men. Soldiers, voyageurs and Native American allies made up the group, which traveled via the northern lakes—up the St. Lawrence River to Lake Huron and then down through Lake St. Clair. They landed at what is now the foot of Shelby Street on the Detroit River on July 24, 1701, and immediately began setting up fortifications and a small church of wooden stakes propped vertically. Although Cadillac's landing at Detroit is much celebrated now, at the time, there was little to distinguish the fort from any other small settlement in New France—and the fort would remain small and obscure for many decades.

At Detroit, Cadillac continued his practice of extortion and smuggling, many miles away from the watchful eyes of government overseers. His habits of exaggeration and braggadocio continued apace; he declared that over the first winter at Detroit, six thousand settlers were inhabiting the site. Historians agree that the number was likely a fraction of that. Before winter, an important treaty had been passed in Montreal between the French government and more than forty First Nations tribes; this allowed the settlement to go forward, although the peace at Detroit was a tenuous one.

Having barely established his colony, Cadillac left in 1702 for Quebec to continue his manipulations; he secured a complete trade monopoly on behalf of the Company of Merchants, then operating in the area. Calling the company "beggarly and chimerical," Cadillac insisted that he was the only man qualified to conduct trade around the lower Great Lakes. He also requested that he be made governor of Detroit. Aside from the alleged scheming of the company, he declared that the Jesuits, including his great rival Father Vaillant at Michilimackinac, "have sworn to ruin me in one way or another," but that "the fox sooner or later eats up the hen." Despite the generous percentages granted to Cadillac from his monopoly on official trade, not to mention his massive income from his smuggling activities, nothing was enough for Cadillac. He saw himself beset on all sides from enemies and whined that the only reason that every last tribe had not moved from Michilimackinac to Detroit was that the Jesuits were holding them behind by force.

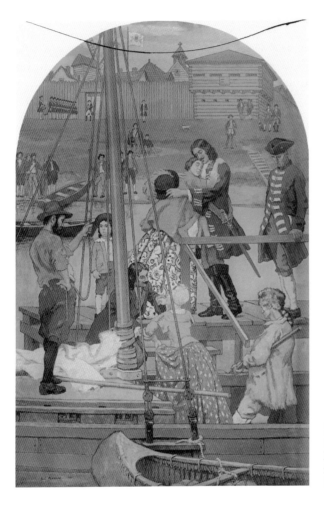

The Landing of Cadillac's Wife, circa 1921. Marie-Therese arrived in Detroit in the fall of 1701. *Library of Congress.*

Cadillac ran Detroit as a private fiefdom. He put the French soldiers to work clearing lands for settlement, then promptly charged them rent to set up houses on the land, all while refusing to supply their food from government funds. By doing so, he hoped to monopolize the entire crop of Huron wheat and corn, charging whatever he wanted for it. Several Ottawa groups had cleared land outside the fort previous to Cadillac's arrival, but Cadillac decided that anyone settling that land must pay him rent as well. He charged rent and percentages for every item and activity in the fort. Use of the fort's only mill, which had been built with military labor, was so expensive that many farmers simply skipped grinding their grain there. For tradesmen, the deal was just as bad. Joseph Parent, the settlement's first blacksmith, paid 600 livres plus two barrels of beer (he

was also the settlement's first brewer) for the privilege of plying his trade and also had to agree to shoe any horse Cadillac brought him. This last wasn't too great a concern, though, because Cadillac kept the only horse in town for years—for which, of course, he charged a high rental fee to anyone wishing to make use of it.

Cadillac had absolute control over all activities at Fort Detroit. Anyone entering or leaving town had to obtain permission from him first and often pay a fee. His profits on trade, meanwhile were upward of 75 percent on high-demand items such as gunpowder and brandy. His petty battles with the Jesuits continued apace, as did the accusations of fraud and theft from both sides. Those who disagreed with or challenged Cadillac's authority were often jailed. Uproar erupted at the fort when an investigator sent to check out claims of gross misconduct was locked up by Cadillac for just long enough for Cadillac's crony Radisson to hide the incriminating evidence and letters.

Meanwhile, the feud with the Jesuits continued. Father Francois Vaillant, who had accompanied Cadillac and the initial landing party, was disgusted enough by Cadillac's behavior that he immediately left the settlement for Michilimackinac. From there, Vaillant sent dispatch after dispatch to Montreal, Quebec and the French Court detailing Cadillac's atrocities. By luring the Ottawa, Huron, Potawatomi and Miami tribes from Michilimackinac to Detroit, Vaillant insisted, Cadillac created a dangerous imbalance and disrupted the delicate agreements between tribes.

Soon enough, the powder keg blew. On June 6, 1706, just outside the fort's stockade, a dog belonging to one of the Miami inhabitants bit an Ottawa man. When the Ottawa man kicked the dog, the fort's temporary commander, Etienne Venyard, Sieur du Bourgmont (Cadillac was in Quebec at the time), beat the Ottawa man so severely that he died. Father Nicholas Bernardin Constantin de L'Halle, the first pastor of St. Anne's, was tending his garden outside the fort at the time. The Ottawa, enraged at the treatment of their own, seized L'Halle but soon released him. He was then mistakenly shot by an Ottawa. Bourgmont ordered his men to fire on the Ottawa. Thirty were killed, and the Ottawa besieged the fort for nearly a month after that. The French rallied the Huron and Miami outside the fort to their cause and put down the Ottawa rebellion.

This wasn't the end of what became known as the Le Pesant Affair. On his return, Cadillac was forced to pay out massive amounts of bribes to the area tribes to establish a shaky truce—for which, of course, he later billed the Crown at a substantial markup. The area around Detroit

was by this point laid waste and home to a few small families; all the rest had retreated to their individual reinforced encampments. According to the custom at the time, the Ottawa eventually surrendered their chief, Le Pesant, to Cadillac's justice. The Huron and Miami called for his immediate execution. Instead, Cadillac engineered to have Le Pesant escape from custody, despite the fact that Le Pesant was a rather corpulent and slow-moving seventy-year-old.

Incensed at the miscarriage of justice, the Miami attacked Detroit, killing three French settlers. More dangerously, they attempted to draw the powerful and numerous Iroquois into the conflict—fortunately for the fate of Detroit, they failed at this. Refusing to hand over the men responsible for the deaths of the Frenchmen, the Miami retreated to their own lightly barricaded fort outside Detroit. Forced into action, Cadillac mustered four hundred men, French and Ottawa, and marched on the Miami encampment. A later, scathing account by Intendant Vaudreuil at Quebec claimed that Cadillac had every reason to believe the Miami were not at the camp at the time, so the march was a ruse by Cadillac to placate his critics while not directly endangering himself.

Instead, Cadillac and his forces found the Miami at the encampment, ready and armed, if not nearly as numerous as the attacking force. Cadillac ordered an attack, then recanted. He had, as it turned out, neglected to bring powder for his guns. When he eventually managed to procure some, he ordered his men forward, but according to Vaudreuil, "[D]uring all this time, the said Sr. de la Mothe, for fear he should get wounded, stationed himself behind a tree which was eighteen feet in circumference, nor did he venture out except to go and get out of range of the shot."[5] Vaudreuil remained convinced that the Miami force was paltry enough that sixty men with swords could have taken it. The Miami raised the French flag and surrendered three hostages as well as a large load of beaver skins, and thus ended Cadillac's only major conflict as commander of Detroit. The hostages, much like Le Pesant, were allowed free reign of the fort and Detroit. The beaver skins Cadillac kept for himself.

By now, Cadillac's faults were overwhelmingly obvious, and recrimination soon followed. Soon, that is, at the pace of dispatches from Detroit to Michilimackinac to Montreal to Quebec to France and back again. Cadillac's superiors complained of his incessant demands, his greed, his mistreatment of all around him and his constant grasping for more. He had brought the entire colony of the Great Lakes to the brink of war. Meanwhile, he made himself ever richer at the expense of

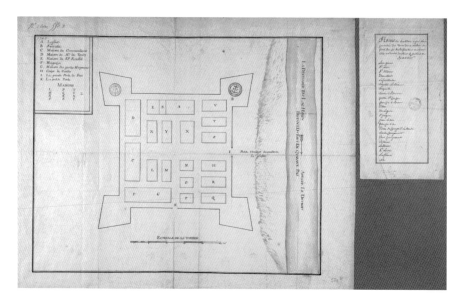

Plan of Fort Detroit. *Library and Archives of Canada.*

everyone. Cadillac was, according to Vaudreuil, "equally detested by the troops, the settlers, and the savages, who have neither respect nor regard for him, looking upon him as a very selfish man, to say nothing more."[6] Vaudreuil remained convinced that the entire Le Pesant debacle could be laid at Cadillac's feet for his mismanagement of trade and his disregard for alliances with the tribes settled nearby.

The Jesuits were convinced that if Cadillac had one of their own established at the fort, much of the violence could have been prevented. They had a point: just before the conflict erupted, Cadillac ordered the removal of a Jesuit who had been living with the Miami for nineteen years. In his place, he installed a Recollet priest, who did not speak the language and seldom left the safe confines of the fort.

Aggrieved by the constant infighting in the colony, in 1708, Pontchartrain appointed a special investigator, Francoise Clairambault d'Aigremont, to look into the pesky Cadillac. His report was, to say the least, unfavorable. Cadillac, d'Aigremont declared, was "generally hated by all the French people and by the savages." His "outrageous exactions" were strangling the settlement and encouraging the allied First Nations tribes to defect to the British. Cadillac had become so stingy that he refused to pay for food or medical supplies for his soldiers. He held such a tight grip on the

brandy supply that traders who legitimately owned brandy had to pay for the privilege of storing it in Cadillac's warehouses—then pay again for the privilege of accessing it for trade. Even then, every drop must be meted out inside the warehouse, and Cadillac's agent lost up to one-third of this supply to leakage.

Cadillac's distribution of land came under fire as well. By 1707, he was granting property rights not his to dole out. Cadillac was convinced, and would remain so for the next two decades, that his trade agreement with the Crown granted him full and perpetual ownership of all lands within hundreds of miles of the fort (which was by this time down to sixty-three settlers). He insisted, in repeated and increasingly petulant letters, that he be named alternately marquis, count, grand governor and other inflated titles. He considered building himself and his children a grand castle at Detroit.

It took d'Aigremont only nineteen days in July and August 1708 to conclude that Cadillac should be removed without delay. "Any longer conversation with him," he declared, "whose disposition is secretive and full of cunning, could only make me more doubtful about things which it was my business to learn." Nonplussed, Cadillac kept up the offensive, calling the combined enmity of the Jesuits, the First Nations, the colonial and royal governors "pettifogging squabbles."

In September 1710, Louis XIV ordered the outpost at Detroit disbanded and appointed Cadillac the governor of the Louisiana Territories. By then, the fort was nearly empty of soldiers anyway, but ten of them still managed to wriggle out from Cadillac's oversight and desert into the woods just before the convoy was to take them to Quebec. They returned days later, and Cadillac allowed them to remain in the settlement without punishment. Cadillac was ordered to travel immediately by land to his new territories.

Instead, as was his habit, Cadillac dawdled about the settlement for the winter, taking inventory of every last cow, axe and grain of wheat in his vast properties. He whiled away the winter writing even more letters of complaint, insisting that his successor was creating egregious "acts of violence and theft" against his person and property. Rather than heading to Louisiana as ordered, in the spring of 1711, he instead traveled to Montreal and Quebec, where he filed yet more claims on titles and properties in Detroit. From there, he went to France to make arrangements with Antoine Crozat, a French financier, to purchase the trading rights to the Louisiana Territories. In addition to his role as governor, Cadillac

would act as Crozat's emissary in the New World, where he promised vast natural resources and even more wealth, so long as Crozat trusted him to carry out his business with little interference. Crozat purchased a fifteen-year trade monopoly on the Louisiana Territories, and Cadillac finally arrived at his new outpost in June 1713, nearly three years after his appointment to the position.

In Louisiana, Cadillac pursued much the same trajectory he had in the north. Disdainful of the priests and settlers, he derided them as "a mass of rapscallions from Canada, a cutthroat set, with no respect for religion, and abandoned in vice."[7] Cadillac quarreled with his predecessor, the respected Jean-Baptiste le Moyne, Sieur de Bienville. Their mutual hatred was so intense that, according to some sources, after Bienville refused to marry Cadillac's daughter, Cadillac sent Bienville off on a dangerous war against the Natchez Indians in the hope that Bienville would either be disgraced or killed. Instead, Bienville returned triumphant.

Cadillac spent very little time at the seat of his new territory, in what is now Mobile, Alabama. Having made wild promises to his new benefactor Crozat, he set out for Illinois to find what he'd already sold to Crozat as a massive and profitable reserve of silver, there for the taking. It never materialized. He continued his practice of selling off land he had no rights to and illegally trading with enemies of France. He also sent a failed expedition to Texas and the Rio Grande in the middle of a war. In the span of three years, Cadillac managed to lose his patron a staggering one million livres; despite having complete monopoly of trade for fifteen years, Crozat relinquished his claim to Scottish gambler John Law in 1717.

Cadillac had by then been removed of his command at Louisiana and allowed the choice of returning to Quebec or Paris. Before he departed, Cadillac took the time to rail against Law's attempts to lure new investors and settlers by claiming vast riches and easy living—the same claims that Cadillac had made to Crozat in order to secure his patronage. Cadillac returned to France in September 1717. Upon his arrival, he and his eldest son were promptly arrested and clapped into chains in the Bastille. They languished there for four months on charges of "speaking against the government of the state and the colonies." Among all the crimes he committed, it is perhaps ironic that what finally landed Cadillac in prison is his disagreement with his own wild claims.

Cadillac spent the next four years, as he had spent much of his time since leaving Detroit, in endless lawsuits against any and all, in order to grasp for himself whatever he could of the lands and properties at Detroit. Finally,

at the end of 1721, King Louis XV ruled that Cadillac had no rights to property in the New World but that a sum of money was due to him in compensation for what he had lost. The king also threw in the Cross of the Order of St. Louis, a new title available to officers of the Crown who served ten or more years. Antoine Laumet de la Mothe, Sieur de Cadillac, was finally granted the nobility he had pretended to all these years. In 1723, Cadillac bought the mayoralty of Castelsarrasin, just across the river from his childhood home of St. Nicolas-de-Grave. He died there on October 15, 1730, at age seventy-two.

2

JOSEPH CAMPAU

Excommunicant Extraordinaire

*B*orn into one of Detroit's premier families, Joseph Campau saw Detroit's rise from a sleepy French backwater to an American powerhouse of ingenuity and industry. Over the course of his ninety-four years, he witnessed three major American wars and saw Detroit's population grow from two thousand inhabitants to nearly forty-six thousnad. From his vast property on the northeast side of the city, Campau stood watch as Detroit became a modern American metropolis.

He also had a rather large and not entirely generous hand in shaping the course of the city of his birth. To one biographer, he was "the soul of integrity" who was "liberal and indulgent" to his many tenants.[8] To another, Campau was an "unrepentant, contumacious and rebellious" eccentric who challenged authority at every turn. By turns extolled as a champion of the poor and derided as a stingy heretic, Joseph Campau left a complicated legacy.

Joseph Campau was born on February 20, 1769, to Jacques Campau, the son of one of Cadillac's most trusted settlers, and Catherine Menard. As there was little formal education to be had at the sleepy riverside town, Joseph was sent to Montreal at age ten for formal schooling. By the time he returned in 1786, he was ready to jump into business. He entered a partnership with a shopkeeper on Ste. Anne Street (later Jefferson Avenue) named McGregor. As a scion of the old French families, Campau soon had plenty of trade, and by 1792, he had his own store on the waterfront with living quarters overhead.

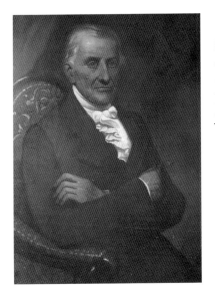

Photo portrait of Joseph Campau.
Burton Historical Collection.

The life of a shopkeeper and trader in early Detroit was an interesting one to say the least and doubly so for Campau and his French Detroit peers. Detroit had fallen into British hands just a few years before he was born, and the dynamics between French habitants, British settlers, the various Native American tribes settled around and visiting the fort and the new influx of Americans after the Revolutionary War made for a host of complications. Campau struck out in business with the help of his brothers, who were fur traders and backwoods travelers. His connections in Montreal, Boston and among the Native Americans and the old French trappers brought near-instant wealth. From his posts in Detroit, Saginaw and on the Clinton River, he sold guns, powder, sugar, cloth, nails and other sundries, as well as plenty of whiskey, rum and brandy. Using the profits, he started buying up property and never let up.

At one point, Campau laid claim to more than one thousand acres on the far east side of the city and another five hundred acres in Springwells on the southwest side. This he rented out to enterprising settlers, although it was well known that Campau always purchased and leased but never sold, as far as his precious land went. Tall and lean, always clean-shaven, Campau presented a striking figure at his storefront and to his tenants in his ubiquitous long black coat and pristine vest, with his record book always on hand. He kept meticulous records of every single transaction, usually in his native French, although he spoke English as well with the French patois of an earlier age.

General Friend Palmer, in his account of Detroit in 1827, painted a picture of Campau's store and the frequent Native American visitors. To the modern reader, it is horribly bigoted, and indeed, Campau and his contemporaries held a very different view of the racial makeup of the city:

> [The Native Americans] *were perfectly peaceable, creating no disturbance, although one might think so from the fact that they were all so*

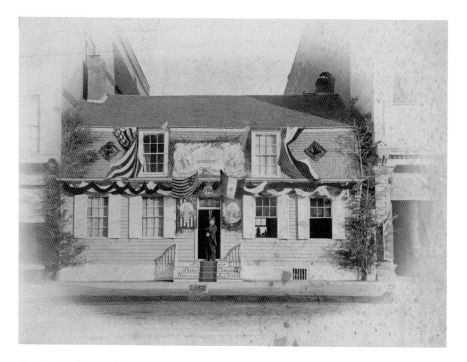

The Joseph Campau House decorated for the Fourth of July in 1876. Campau built the home for his children in 1835. *Burton Historical Collection.*

addicted to the use of whiskey. They were all great friends of Mr. Joseph Campau and he of them, who had his store and dwelling on Jefferson Avenue, east side, between Griswold and Shelby streets. I have often seen the sidewalk in front of his place so crowded with them lying around that it was difficult for pedestrians to get along without stepping on a squaw or pappoose [sic].[9]

Notwithstanding the casual racism of Palmer and other chroniclers, Campau's friendliness to the Native American settlers and traders caused repeated trouble for himself and his family. Frequently accused of exceeding the limit of rations allowed for trade with the nearby tribes, Campau was known to be generous to a fault with the whiskey, which caused no end of hassle with the settlement's French priest, the saintly Father Gabriel Richard.

In fact, Campau's troubling history with those people not of French or British descent went beyond his occasional skirting of liquor laws. Campau, like several of the other wealthy French families of old Detroit, owned several enslaved people, both Native American and African American. Most

records seem to indicate that Campau owned approximately ten enslaved people in the course of his long life; among them were a young man named Crow, whom Campau fitted out in scarlet robes, and a married couple named Hannah and Patterson. Several he purchased in Montreal, for, as we see with the stories of Augustus Woodward and William Hull, slavery was commonly practiced despite the territorial laws against it. The 1796 census recorded three hundred slaves in the city of Detroit.[10]

Of those three hundred, late one night in 1792, an enslaved man known as Josiah Cutten, also known as Joseph Cotton, broke into Campau's store and made off with some bills of sale as well as other small items. Campau turned him over to the government of Upper Canada, which had been newly formed, and Cutten became the first man executed in the new territory. A harsh penalty for the theft of a few items, but Cutten's treatment is evidence of the patterns of slavery and bigotry existing in Campau's time. Campau and his family continued to hold black "servants" well into the 1830s, long after it had been outlawed in Michigan.[11]

By 1800, Campau's wealth was increasing at an exponential pace, although we can't say the same of his philanthropy. That year, his elderly uncle Jean Baptiste lay dying, and rather than take time from his profitable ventures, Campau left the care of the invalid to his cousin Gabriel Chene, Jean Baptiste's son-in-law. In consequence, a great portion of the Campau estate was passed on to Chene. It's nice to imagine that this little bit of justice was a thorn in Campau's side, although nowhere near great enough to make up for his other crimes.

Increasingly incensed with Father Richard's criticism from the pulpit over the liquor issue, Campau was not one to skirt conflict. He broke tradition and Catholic law by entering the Order of Freemasons in 1800. The Freemasons, mostly composed of English and American planters and merchants of wealth, offered Campau more trade connections. Campau took advantage of these connections and quickly piled up city appointments; in 1802, he was made a trustee of the city and, at later times served as assessor, appraiser, inspector of water barrels, city treasurer and other prestigious—and profitable—positions in the city. And although he was granted several military commissions, in 1806 and later during the War of 1812, Campau preferred to stay close to home and closely monitor his trade interests.

By 1802, Campau had a young ally in his ventures, his sister's son John R. Williams. Campau minded the business interests at home while Williams, who would later become Detroit's first official mayor, took over the trips to Montreal and parts east. It didn't take long for the hotheaded

Williams to get himself into trouble: on his first trip to Montreal, Williams joined up with a fellow Detroit merchant named La Salle and commenced a rowdy drinking binge. The two had a falling out, and the subsequent duel left La Salle injured and Williams languishing in a Montreal prison for months. Despite the early setback, Campau and Williams's partnership proved advantageous to both of them throughout their careers, especially when Williams happened to be appointed as arbitrator of land disputes just as Campau was engaged in a lengthy lawsuit over the provenance of several plots of fertile land.

Campau was no stranger to lawsuits. His many black notebooks detail claims, grievances and squabbles with several Detroiters, including distiller Henry Conner, with whom he'd set up business in 1802, and Major Antoine Dequindre, for nonpayment of some dubious debts.

All these petty problems fell by the wayside, though, after June 11, 1805. Shortly before dawn, a stable near baker John Harvey's warehouse caught fire. Soon, the entire town was engulfed in flames, and residents dashed to save what they could from the roaring blaze. Panicked citizens boarded boats and threw their most prized possessions in the river. Remarkably, no one was killed in the great fire, but the entire town was leveled. Only one warehouse on the southwest side of town and a few stone chimneys remained.

Campau's home and warehouse, like the rest of Detroit, were leveled to ashes. Ste. Anne's Church was another casualty of the fire, and Father Richard wasted no time in organizing food and shelter for the devastated city. He held church services in the surviving warehouse, and plans were soon underway to rebuild the city. Just a few weeks after the fire, the territory's new government officials, Judge Augustus Woodward and Governor William Hull, arrived and began making over the city according to Woodward's grand plan. Woodward's plan was designed after Parisian streets and the then new national capital, Washington, D.C. The only problem, discussed further in the following chapter, was that the citizens of Detroit had a rather loose arrangement when it came to property claims.

Campau saw his opportunity to shape the new city's plan to his benefit. Why, he argued, should the old French contingent on the northeast side of town—the Côté du Nord-Est, as it was called—have to suffer through a long walk just to get to church on a Sunday? It just so happened that a wealthy landowner who lived outside of town, François Paul Melcher, was looking to sell his property near what is now the Belle Isle Bridge, at Jefferson and Van Dyke. Even Campau couldn't afford the asking price for

A map of the Great Lakes, 1813. *Library and Archives of Canada.*

the large estate (or at least that's what he told his fellow North Coasters), so he organized a cooperative of eighty-eight residents to band together and buy Melcher's farm.

Framing the land grab as an appeal for Christian charity, Campau and his cohorts tendered a proposal to the new city officials: Ste. Anne's could stay in the southwest part of town, or it could move to this lovely new location. Admittedly, the spot was a bit of a hike from the center of town, but it was convenient to Campau's store. Campau's cooperative would be happy, he offered, to grant the church use of the space for a reasonable fee. The church's proposed new site, according to Woodward's plan, was to be at Cadillac Square and would require the disinterment and reburial of several of the oldest graves in town in order to widen Jefferson.

Seizing the opportunity for outrage, Campau composed a letter of complaint to Woodward and Hull:

> *We appeal to the humanity of our fellow citizens to decide whether it would not evince in the highest degree a want of those humane and charitable qualities which are and ought to be the peculiar characteristics of Christians were we to abandon for the purpose of a common highway the earth in whose bosom reposes the remains of our fathers, our mothers and common kindred. O Sympathy! O Nature! Where are thy Godlike Virtues by which the great Author of the Universe has distinguished Man!*[12]

So began the scandal that would drag on for many years—as late, in fact, as 1909. As it turned out, several of the citizens who had signed Campau's petition had not read it carefully and soon fired off their own letter to the higher-ups, essentially disavowing their involvement in the

fiasco. Campau, however, held out, along with Williams and several others. Conspicuously, Father Richard was left out of the group's negotiations and complained bitterly—and with reason. Richard had enough on his hands, what with rebuilding the city; creating schools for boys, girls and the town's Native American inhabitants; introducing Detroit's first printing press and university; caring for the sick; and crafting the city's new motto (*Speramus Meliora; Resurget Cineribus*: "We hope for better things; it will arise from the ashes").

Campau, undaunted, thwarted Richard's attempts to rebuild at every turn. A visiting bishop lamented, "I have reason to believe that the people's inordinate love of social pleasures, evening gatherings, and dances, was the cause of their immorality, idleness and extreme poverty."[13] Certainly, Campau encouraged his peers on the Côté du Nord-Est to distinguish themselves from the common lot gathered in the center of town. He used all the power of his considerable social and monetary capital to pressure the church into selecting the Melcher land as the site for the city's new chapel. Barring that, he insisted, the citizens of the Nordest deserved to have their own chapel and priest, although he declined to pay for the salary and upkeep of this proposed chaplain.

A statue of Gabriel Richard on Jefferson Avenue. *Photo by Dan Archer.*

Richard, at his wits' end, continued to hold services in the makeshift chapel/warehouse while the legal claims for the Melcher property dragged on. Meanwhile, events in the greater world intruded and delayed the resolution of the issue at Ste. Anne's. In 1808, the thirty-nine-year-old Campau married Adelaide Dequindre, another member of the mercantile elite. There seemed to be no hard feelings between Campau and his in-laws, despite the fact that he had sued Adelaide's father years before over a debt. The Campaus had twelve children, all raised as good Catholics by the devout Adelaide. Campau continued to attend Mass for some years, despite Father Richard's insistence that he repudiate his membership in the Freemasons.

The 1807 Treaty of Detroit, in which the majority of the lands of southeast Michigan were ceded to the new Michigan Territory for two cents an acre by the Ottawa, Chippewa, Wyandotte and Potawatomi tribes, compelled Governor Hull to initiate a survey of property rights. The survey, conducted by Aaron Greely, immediately ran into complications. Land ownership in Michigan Territory was a rather laissez-faire arrangement, and many deeds were transferred via handshake and gentlemen's agreement rather than official channels. Woodward would later complain that there were only eight documented land titles in all of Detroit in 1806. The rest took years to sort out. Fortunately for Campau, his nephew John R. Williams, having mellowed considerably after his Montreal duel and imprisonment, was moving speedily up the political ladder and used his considerable influence to steer negotiations in his uncle's favor. He held later appointments as associate justice of Wayne County (1815), county commissioner (1815) and Detroit's first elected mayor (1824).

In 1808, several of Campau's complainants testified that he was enforcing squatter's rights over vast tracts of territory that he had no official legal claim to, including five claims for over one thousand acres near the Clinton River. Campau, like Cadillac before him, was labeled a slum landlord who extracted double-compound interest on loans and refused to sell off property, instead leaving the lands to be cleared and cultivated by tenants who were only allowed temporary leases. The surveyor Greely, after trying to get to the bottom of Campau's many deeds, eventually washed his hands of the affair, declaring, "I am sorry Campeau [sic] and Williams have exerted themselves to the injury of these ignorant French Inhabitants," and decided "Campeau must (for me) transact his own land affairs."[14] Greely was increasingly worried about the tensions between British and American forces developing in the Great Lakes and ominously concluded, "War will certainly take place."

By 1812, the citizens of Detroit had other things on their minds than squabbles over property rights. The War of 1812, as detailed in other chapters, turned the city upside down. Williams was active in the defense of Michigan Territory and was one of the first hostages taken after the surrender of Detroit on August 16, 1812. He spent several years in Albany before returning to a city completely changed by the war. British general Procter's treatment of Detroiters was designed to cow them into submission. Most Detroiters were too busy scrambling for food or seeking protection from frequent attacks by Procter's troops and Wyandotte allies to worry about which piece of burned-out field belonged to whom.

Although Campau was commissioned as a major during the War of 1812, he spent far more time marshaling his financial resources than he did on any battlefields. In 1812, he formed a partnership with John Jacob Astor of the immensely wealthy American Fur Trading Company. The timing was far from ideal, however, as the war and subsequent British occupation froze up trading routes across the Great Lakes.

After General William Henry Harrison recaptured Detroit in September 1813, Campau resumed his attempts to establish the Côte du Nord-Est as the center of commercial and religious activity in Detroit. Richard, who had been imprisoned by the British for refusing to sign an oath of allegiance, was eventually released and continued his combative stance against Campau. His objections were sporadic, however, as he was the only ministering priest in Michigan at the time and had vast territory to cover. Richard traveled to Baltimore to petition the archbishop for resolution of the affair so that he could build the cathedral that the growing city was now in desperate need of.

In 1816, the residents of the northeast coast and Richard finally settled into an uneasy agreement, in which Richard would indeed build the new church on Cadillac Square but the French settlers of the northeast would be allowed to hold a chapel on the Melcher property, albeit without a dedicated priest. A separate parish was promised by the bishop of the territory, Flaget, so long as Campau and his peers would accept the new church grounds and cease their protests over the removal of their ancestors' remains.

Instead, in 1817, an unnamed group interrupted the groundbreaking ceremony with wild shouting and proceeded to shovel the dirt right back into the graves as fast as it was dug out. Campau, as well as seven other ringleaders, were promptly excommunicated from the Catholic Church and their chapel placed under interdict.

By now, Bishop Flaget had enough of the unruly northerners. He himself marched into town on June 1, 1818, surrounded by a military escort. After

days of negotiation, Bishop Flaget declared the interdict lifted from the northeast chapel, and all excommunicants were welcomed back into the arms of the church—except for Joseph Campau. A daylong celebration ensued, and the entire town, Catholic and Protestant, American and old French, marched throughout the town singing hymns and waving banners. Except for Joseph Campau. The wily Frenchman remained bitterly opposed to the Catholic Church until the end of his days, and he pursued his suits against church and civilian property owners for many years to come.

The affair of the Melcher lands was nearly settled in 1834 when the stockholders of the land deeded the property to the church at last, after Campau had reopened the suit with a request to divvy up the lots for sale. But in 1857, a group of lawyers again entered legal documents claiming that the original terms of the deed had not been fulfilled. At this time, it was discovered that, since the original deed-holders were all deceased (Campau had sold off his portion to someone else), the deed could not be found. The diocese was only able to salvage a total of 117 acres from the massive plot, and a suit as late as 1909 by the church was again unsuccessful.

Campau had, in many respects, won his battle with Father Richard. He had prospered several times over from his wily manipulations of his fellow habitants, and aside from his own apostate status, the rest of his family was in excellent standing with the church. In 1831, Campau and Williams purchased the publishing equipment of the *Pontiac Oakland Chronicle* and launched the *Democratic Free Press* and *Michigan Intelligencer*. Soon renamed the *Detroit Free Press*, it was the city's first daily newspaper. Not long after, the pair turned operations over to publisher and editor Sheldon McNight.

With the favorable opinions of the press, the mayor and his Masonic connections, Campau enjoyed unparalleled freedom and prosperity. He continued to gobble up lands, and although the lawsuits continued apace, most were favorably resolved thanks to Campau's connections. In 1832, Campau sued city leaders to clear an eyesore on Griswold Street downtown, not far from the cathedral at Ste. Anne's. An abandoned building had burned down and had been spilling garbage and rubble into the street and onto Campau's property, blocking traffic. By the time Judge Solomon Sibley, an old friend of Campau, heard the case, the rubble had been cleared, but the court still ruled in his favor and he was granted over $2000 for his trouble.

The occasional lawsuit aside, Campau gradually ceded his business and property management to his sons, in particular Daniel Joseph. He still held tight to his account books, however, and his stooped, crow-like

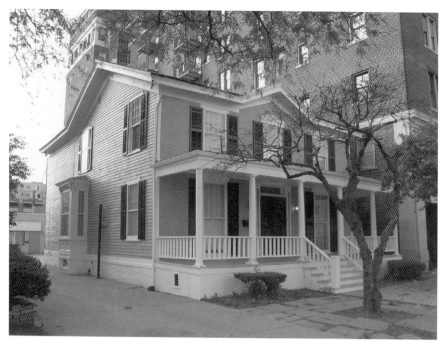

Above: The Joseph Campau house still stands on Jefferson. *Photo by Andrew Jameson.*

Left: Joseph Campau's grave in Elmwood. *Photo by the author.*

Opposite: Joseph Campau's grave in Elmwood. *Photo by the author.*

form could for many years be spotted leaning out the half door of the second floor of his shop on Jefferson. In his later years, he became the town eccentric, a somewhat comical figure in his flapping coat and ruffled sleeves of a bygone era. Campau had lived through the Revolutionary War and the War of 1812 and would see much of the Civil War. He witnessed countless settlers from around the world invade his sleepy little French village. He was more than willing to share stories of the olden times with his close friends and allies, although he remained cool, even cantankerous, to those he viewed as newcomers. In his final few years, as he approached the century mark, his heirs finally and reluctantly had him declared incompetent due to old age, though they indulged his habit of bringing his notebooks everywhere, pouring over old transactions and recording new ones.

When Joseph Campau died, fittingly enough, just a day shy of the anniversary of Detroit's founding on July 23, 1863, the *Free Press* lauded him as the last of the great French mercantile giants. His obituary declared him an "honest, prudent, temperate, and sagacious," and his funeral gathering was the largest seen in Detroit until that time. Unrepentant and excommunicated from the Catholic Church until the end, Joseph Campau was buried at the Protestant Elmwood Cemetery, just yards away from the rest of his family.

AUGUSTUS WOODWARD

Brilliant Incompetent

*A*n undisputed genius whose capacity for abstract thought was generations ahead of his time. A filthy drunk whose antics brought shame on his office and on his constituents. Savior of the people in the most desperate of times. Greedy land speculator who confiscated property from the innocent French landowners of Detroit. All of these opinions were published in contemporary accounts and later histories of Elias (Augustus) Brevoort Woodward. One of Detroit's most colorful characters, he combined brilliance and absurdity in equal measure to ensure that his legacy would continue long after he left the city. During his time in Detroit, Woodward shaped the very foundations of the city and arbitrated legislation that would dictate American policy.

Despite his impact on Detroit and on American history, little of Woodward is remembered today aside from the street that bears his name. Born in New York City in November 1774 to a luxury goods importer and his wife, whose Dutch family was one of the oldest and wealthiest in the city, Elias Woodward witnessed from very early on how quickly fortunes can change. When Woodward's father joined the Revolutionary War in support of American independence, his Loyalist landlord confiscated the store and its contents, leaving the Woodward family destitute. The family's fortunes never recovered, although the young boy's namesake uncle, Elias Brevoort, paid for his education at Columbia College. While there, Elias adopted the name Augustus, an early sign of his grandiose view of himself.

At school, Woodward demonstrated an early brilliance in arguing complex legal cases and examining the intricacies of topics as varied as city planning and national governance. He also started exhibiting some of the behaviors that would cause him so much trouble later in life. Writing in his journal, Woodward declared, "I want no constant intercourse, no unwise familiarity. I must be respectful but reserved, never rude, but never relaxed."[15] Woodward was a puzzlement to his peers. His appearance and manner of dress set tongues wagging wherever he went. Topping six feet, three inches, he devoted lavish attention to his hair and clothing but was exceedingly neglectful of personal hygiene. According to later biographer Silas Farmer:

> *The judge was very tall, with a sallow complexion, and usually appeared in court with a long, loose overcoat, or a swallow-tailed coat with brass buttons, a red cravat, a buff vest, which was always open and from which protruded an immense mass of ruffles. These last, together with the broad ruffles at his wrists, were invariably soiled. His pantaloons hung in folds to his feet, meeting a pair of boots which were always well greased. His hair received his special attention and on court days gave evidence of the best efforts of the one tonsorial artist of the town. He was never known to be fully under the influence of liquor, but always kept a glass of brandy on the bench before him. In the evenings he would go to Mack & Conant's store (which was on the north side of Jefferson avenue, between Woodward avenue and Griswold street) and sit and talk and smoke his pipe and sip half a pint of whisky until it was gone.*[16]

Woodward's eccentric appearance and behavior didn't stop him from moving up the social ladder. After graduating from Columbia College, he practiced law in Philadelphia, where he was able to move his impoverished parents and sister. When his benefactor and uncle Elias Brevoort died in 1797, he left Woodward a small inheritance, which Woodward immediately seized and took to the burgeoning new capital at Washington in the new District of Columbia. There he bought property on Pennsylvania Avenue close to the White House construction site and set up a new law practice. Woodward made several important social connections in Washington, none of which was to have more influence on his life than Thomas Jefferson. Jefferson might have seen something of himself in the gawky youngster, since by many accounts, Jefferson's personal behavior was erratic bordering on the obsessive.

Like Woodward, he was slovenly in his personal habits but exceedingly meticulous in his professional life.

The two had met as early as 1795, and Woodward's trips to Monticello would continue throughout his life, even when pressing matters in Michigan might have been demanding his attention. During his time in Washington, Woodward advocated for representation of the District of Columbia's citizens in Congress, arguing that the city's inhabitants should have voting rights similar to the states. He published a series of pamphlets, *Considerations on the Government of the Territory of Columbia*, that constitutional scholars still occasionally refer to today. In 1802, Woodward was elected to Washington's first city council, which served under an appointed mayor. After serving less than one full term, however, Woodward became

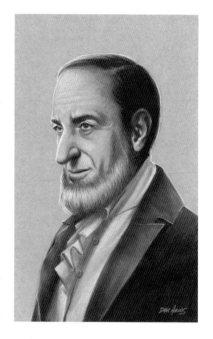

Artist's rendering of Augustus Woodward, based on descriptions by his contemporaries. *By David Aikens, author's collection.*

disillusioned with the slow pace of city politics and abdicated his position; it was to be the first and only elected term of office he served.

His brilliant theoretical mind, however, propelled him to the attention of the elites of the new capital. He was enchanted with the urban plan for the city laid out by Pierre Charles L'Enfant, a Frenchman who had served under Washington in the Revolutionary War and who modeled the new layout after Paris's wide boulevards and radials connected to central hubs. One historian claims that Woodward pasted L'Enfant's drawing of the city into his notebook and carried it with him to his new post in the Northwest Territory.[17]

Woodward's political connections soon paid out, and he was appointed as one of three supreme court justices for the Territory of Michigan, which was officially established on June 30, 1805—the day that Woodward arrived in Detroit. Serving under Territorial Governor William Hull, another East Coast elite, Woodward entered uncharted territory, both personally and physically.

Woodward arrived to a scene of chaos and devastation. The June 11, 1805 fire had leveled the city, leaving only a single building standing. Woodward's

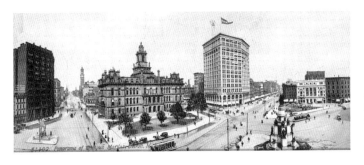

Artist's rendering of the Great Fire of 1805. *Library of Congress.*

co-justice, Frederick Bates, had been in Detroit since at least 1797; until Woodward and Hull arrived with the proper paperwork, however, Bates had no legal power to order the cleanup efforts in Detroit. The territory's third appointed justice, Samuel Huntington, refused the post and was later appointed governor of Ohio. Eventually, John Griffin would take up the third position, although his leadership ability was essentially nonexistent, and he simply followed Woodward's lead throughout the course of his lackluster career on the bench.

Faced with the daunting task of organizing the citizens and rebuilding, Woodward thought big. In fact, he thought on a scale far grander than the city would realize for more than a century. Taking L'Enfant's elegant design for Washington, D.C., as inspiration, Woodward drew out a grand plan of interlocking parts, grounded by radial avenues emanating from periodic grand circuses and parks. Never mind that the town had only eight hundred or so inhabitants; Woodward dreamed of a city that could encompass millions and stretch for miles in any landward direction. Each block of his city plan could be replicated as the city grew, linked together like Tinkertoys by the center hubs of the parks and the spokes of the avenues. His first plan alone could accommodate fifty thousand residents, a population that would not be seen in Detroit until more than sixty years later.

The greatest problem with Woodward's grand plan, aside from the material cost of laying out miles of boulevards across a wilderness, was with the people of Detroit. Since its founding as a French colony, Detroit's layout was centered on access to the river. Detroiters lived on the river, they conducted commerce there, they drew water for irrigation and they pulled fish from the waters for their frequent parties and feasts. Long, narrow ribbon farms, usually around 250 feet wide at the river and up to three miles long, were the typical plots in Detroit. The primarily French heritage farmers and merchants of Detroit had no interest in elegant 120-foot-wide boulevards, especially if those boulevards were dropped right in the middle

of their farms, forcing them to traverse the empty roads just to plow their fields on the other side.

Oddly, Woodward lacked clear foresight in one matter that would later haunt him. He saw no need, he said, to change the layout or location of the town's fort, situated at what is now the intersection of Fort and Shelby Streets. Although the higher ground did offer some strategic advantage in case of attack from neighboring Native American tribes, its guns were too far from the river to produce an effective defense there. Besides that, many of the town's most important docks and warehouses and store lay directly between the fort and the river. This oversight would prove deadly during the conflicts to arise just a few years later.

Woodward's city plan was likely doomed from the start. He simply thought in too grand a scale, looking forward to a vast metropolis that would not exist for many decades. Addressing the bedraggled and still homeless inhabitants, he adjured them to think of what their town could become in the far future and plan accordingly. Detroit would become, he insisted, a city "thriving with people, characterized by industry and abounding in the production

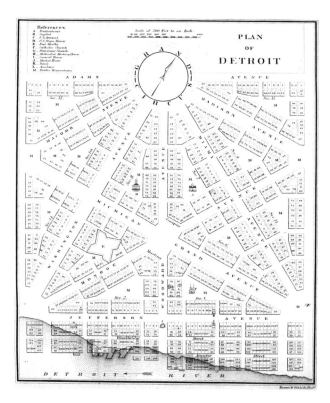

Woodward's plan for the city of Detroit. *Burton Historical Collection.*

and arts which minister to the convenience and comfort of man."[18] All very well and good, Detroiters responded, but there was little convenience and comfort in the current situation.

Woodward's proposal to redraw the city was, to his abstract-thinking mind, a generous one: each white male citizen over the age of seventeen who had lived in the city before the fire was to receive his own plot of land, and the existing property lines were to be redrawn to distribute larger and more evenly spaced farms and orchards to each owner. This action launched years of squabbling, sniping, and accusations of graft and theft. While Woodward hired a Canadian surveyor to take detailed measurements for the grand new streets, Detroiters simply started throwing up homes and barns wherever they saw fit. Sometimes these locations fit with Woodward's plan, but often they did not. The fact that property records and deed transfers in those days were more often conducted via a handshake than a court document complicated investigations into who owned what land as well. The epic battle between Joseph Campau and Gabriel Richard is a fair example of the sort of disputes that plagued Woodward's attempts to strong-arm Detroiters into acceding to his plans.

Frustrated, Woodward did what he often did when faced with intractable Detroiters: he sulked. In October 1805, Woodward and Governor Hull set out to present their new plans to Congress for approval. Woodward stayed in Washington until April of the following year, visiting with family and attending frequent dinners with Jefferson and his cohort. Meanwhile, due to the tangled web of property claims and lawsuits, not a single house was built in Detroit in 1806. A scathing 1807 petition by the citizens laid the blame for the chaos squarely at the feet of Hull and Woodward:

> *The history of William Hull and Augustus B. Woodward since they took upon themselves the Government of this Territory, is a history of repeated injuries, abuses and deceptions, all having a direct tendency to harass, distress and impoverish, if not absolutely to expel the present inhabitants—and to accomplish private and sinister schemes.... They have been guilty of unfeeling cruelty and barbarity by preventing those naked and homeless sufferers by then conflagration, from accommodating themselves with buildings during one whole year, and many of them during another year—and several to this very day—thro' their systematic measures of speculation.... They have by their intrigues and ridiculous manoeuvres [sic], sunk themselves into the deepest contempt—and they are actually at this time, a reproach and bye [sic] word among the people.[19]*

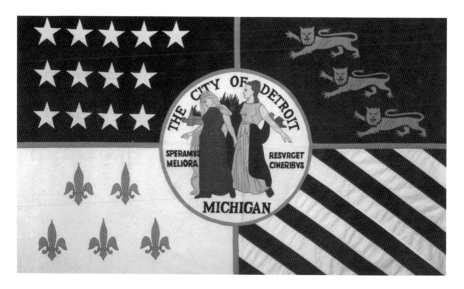

The flag of the City of Detroit, depicting the Great Fire of 1805. *Burton Historical Collection.*

One of those "bye words" used by the people to refer to Hull and Woodward was *Bostonnois*, a French Canadian term ridiculing newly arrived bureaucrats from the East Coast with no working knowledge of life on the frontier. Their critique of Woodward's mismanagement was justified; Woodward was far more concerned with his lofty city plan than he was with caring for the inhabitants, who needed food and shelter immediately.

Inevitably, accusations of graft and profiteering surfaced. One of the first completed buildings in Detroit was Hull's governor's mansion on prime Jefferson Avenue land. While Detroiters were clearing the rubble from the ashes of the fire, James May scavenged the best stone and bricks from the remaining chimneys to build Mansion House on 220 feet of riverfront property. Woodward quickly bought it from May and leased the building as a hotel and boarding complex. Woodward also snatched up property at the far northern outskirts in what was dubbed the Ten Thousand Acre Tract, where he plotted out a model village on 1,280 acres. Portions of the land would become Highland Park long after Woodward had died.

One complainant among many of Woodward's critics stood out from the rest. John Gentle, a Scottish trader who had plied the riverfront for several years before the fire, petitioned Woodward for the same property rights granted to Detroiters after the conflagration. Woodward denied his claim, alleging that Gentle wasn't a citizen and therefore deserved no

land. Gentle took his complaints about the land grants and the later Bank of Detroit scandal to the national papers, issuing a series of blistering parodies that shaped much of our image of Woodward today. In these widely circulated stories, Woodward came off as a grotesque, greedy lout whose lofty language belied his brutish and lecherous character. Although he fought these characterizations for the rest of his life, Woodward could never quite escape this image.

Woodward and Hull were by no means allied in the face of criticism from Detroit's residents. Instead, they engaged in increasingly petty battles of will over whose authority should hold sway in Detroit. Woodward, by now backed by the sycophantic Griffin, held a two-thirds majority in judicial proceedings against Hull's allies, first Bates and then, in 1808, Justice James Witherell. The battle of will between Hull and Woodward effectively squashed all legislative progress in Detroit and ensured that it remained a provincial town beset with supply problems. When Hull, as governor and commander of military forces, formed a militia for the area, he reluctantly appointed Woodward a colonel of the First Regiment of the territorial militia. This appointment lasted for a single campaign, in which Woodward, according to Hull, demonstrated remarkable levels of incompetence and bravado in his impractical placement of battery positions. Disgusted, Woodward gave up his commission and retreated to Frenchtown in modern-day Monroe.

When faced with criticism, Woodward's instinct was to pout, a behavior that was less than helpful in a territory consistently ignored by the federal government. The portrait of Woodward that emerges is that of a man stumbling from crisis to crisis, his nose in the clouds, penning eloquent theories while ignoring his own constituents' cries for practical help. Among the many examples of Woodward's impracticality, the first Detroit Bank debacle demonstrates the complete lack of awareness of how the world really works. When Woodward and Hull traveled back from Washington after their extended 1805–6 visit, they carried with them articles of incorporation to establish a private bank in Detroit, ostensibly backed by investors from the East. These investors, as it was later discovered, had no collateral of their own and relied on loans to seed the bank's funds.

Woodward was named president of the Bank of Detroit and pushed hard for a one-hundred-year bank term, as well as a circulation of $1 million in bills, despite the fact that the actual capital backing the bank was far less than this. He approved the construction of a massive stone building with iron vaults and a sweeping floorplan—despite the fact that the rest

of the city consisted of lean-tos and tents. In retrospect, it is difficult to prove whether Woodward's motives were sinister or whether he was simply gullible, but the bank failed catastrophically and the blame was firmly placed on its president's head. The bank's investors, it turns out, had engineered the whole thing as a scheme to pass valueless notes off in eastern cities with the knowledge that by the time they were redeemed in Detroit they would be Detroit's problem. Woodward emerged from the scandal with his reputation even more tarnished.

During these eventful years, Woodward, along with his lackey Griffin and his antagonists Bates and Witherell, attempted to cobble together a judicial system in the new territory. Like the rest of his actions, Woodward's record in the courts is a mixed bag of lofty ideals and dithering on technicalities. In the fall of 1807, he ruled on two cases that had long-lasting effects on policy not only in Michigan but also in the rest of the new nation. These effects would take more than fifty years to fully emerge.

Michigan's history of slavery is a troubled and complex one and certainly the subject for a much lengthier study than this.[20] With the 1787 establishment of the Territory of Michigan, slavery was ostensibly outlawed; however, property owned by British citizens was protected, including enslaved people, since British law still allowed citizens to hold slaves in North American territories. A British law in 1793 ruled that the children of enslaved people owned by Canadians were to be emancipated at age twenty-five. To complicate the matter even further, the British occupation of Detroit until 1796 created complex property entanglements. In its simplest essence, the question boiled down to what—and who—constituted property in the various treaties and conflicting legal rulings of the contentious years between 1787 and 1796.

The matter came to a head in September 1807. A British property owner named Tucker had purchased an enslaved family in Canada, the Denisons, and later moved them to Detroit. Peter and Hannah Denison had four children. Tucker's will stated that Peter and Hannah would be freed upon the death of Tucker's wife but that their children would remain enslaved. Peter Denison brought the case to court, arguing for the freedom of his children on the basis that the Ordinance of 1787 prohibited slavery.

Woodward's ruling on the case is typical of the way his mind worked. Citing various treaties and complex clauses, Woodward declared that three of the four children, because they were born before 1793, were to remain enslaved. Despite his legal ruling, however, Woodward appeared to hold a

personal abhorrence for slavery in general. He felt himself stymied by his obligation to rule according to the letter of the law, despite how he felt. In a lengthy statement about the Denison ruling, he declared:

> *The Slave trade is unquestionably the greatest of the enormities which have been perpetrated by the human race. The existence at this day of an absolute unqualified Slavery of the human Species in the United States of America is universally and justly considered their greatest and deepest reproach.*[21]

Within a month, Woodward ruled on another case that would have even greater influence on later American legal policy regarding slavery. Jane, age twenty, and Joseph, age eighteen, were ostensibly the property of a merchant from Sandwich, Canada, named Richard Pattinson. When Pattinson took them to Detroit on a trading mission, they escaped to Smyth's Tavern, where Smyth and his patrons protected them from seizure by Pattinson and his companion Matthew Elliott. After Elliott was nearly tarred and feathered—and his employee, James Heward, was, after picking a fight at the tavern—the case went before Woodward and the court. In this case, Woodward interpreted the law to rule that slavery was legal in Michigan only in cases where the enslaved people were already enslaved by British settlers before the Jay Treaty of 1796, or if they were fleeing an American state in which slavery was legal. Since neither held true for Jane and Joseph, they were freed.

The Denison children, hearing the verdict, saw an opportunity. The three eldest were born during that brief window that Woodward had declared permissible for persons to enslave others, but Woodward had effectively ruled that fleeing slaves would not be persecuted. Elizabeth Denison and her siblings promptly crossed into Canada, where they were free from capture by Woodward's ruling, and stayed there for a few years before returning to Detroit, at which point they were practically if not technically emancipated. Elizabeth later went on the become the first woman of color to own property in Detroit and endow a church on Grosse Ile, St. James Episcopal, which still stands. The Woodward ruling, though, also allowed for future slave-catchers to travel to Detroit in pursuit of escapees. Woodward's ruling set up decades of dramatic escape and conflict in the city of Detroit up through the Civil War.

Woodward's attitude toward the Native American inhabitants of the area was equally complicated. Tragically typical of the attitude by American settlers and government at the time, Woodward held a low opinion of the

Ottawa, Potawatomi, Huron and other tribes that lived in the region. This opinion was fueled by colonialist standards as well as real fear of the warfare that often erupted among the various groups and was sometimes directed at the white settlers of Detroit. His legal rulings were troubled primarily by culture and language barriers: each band had its own hierarchy and legal methods, and when Native Americans committed crimes in Detroit, holding court in English by American laws was a futile effort. In one offhanded statement, Woodward casually remarked that "more than one erring brave went to the gallows without the slightest understanding of how he came to be there."[22] Another, later case, might show some evolution in Woodward's thinking, however. In 1822, a Menominee man and a Chippewa man were tried for murder. Neither spoke French or English, and the court couldn't find anyone to translate from either language into English. After a child was brought in to translate from Menominee to French and another from Chippewa into French, yet another translator then rendered these into English; linguistic chaos ensued, and Woodward gave up the whole thing as a lost cause and simply dismissed the case.

His court rulings, as with nearly every other aspect of Woodward's life, show a disconnect between his genius at abstract thinking and his ineffectiveness at practical rule. His tendency to take insult at the slightest provocation didn't help his reputation—nor did his constant petty feuds with Hull. He was also often accused of public drunkenness, with one observer noting that he preferred to hear court cases at Smyth's Tavern with several bottles of brandy on hand. In 1811, Woodward engaged in a brawl with backwoods trader Whitmore Knaggs, a Hull partisan. Although Woodward won the fistfight, he had Knaggs arrested for assault and battery. Woodward refused to recuse himself from ruling on the case and even filed a civil suit for $20,000 in damages. Although that case never went to trial, this and another partisan battle led to increased allegations that Woodward was using his judicial power to rule as a despot in Detroit. At least twice there were petitions sent to Congress demanding Woodward's impeachment.

Soon enough, however, greater matters would intrude on the partisan fights between Woodward and Hull. While Hull was in Massachusetts and Washington from winter 1811 to summer 1812, Woodward and the rest of Detroit cast a wary eye on increasing tension between Native American tribes and setters and on the mounting forces of British soldiers across the river in Canada. The War of 1812 was a brief but consequential affair for the city of Detroit.

Historian Frank Woodford offers a colorful, if perhaps apocryphal, anecdote from the night of August 15, 1812: Woodward, awakened by the cannonade from across the river, leaped up from his bed, only to see a bullet whizz through the wall, hit the bed he had just left and explode the contents of his pillow and bedding across the room and into the fireplace.[23] The battle and its aftermath would draw out all of Woodward's reserves of strength and compassion.

After Hull's surrender of Detroit, Woodward was one of the few men left behind after the British demanded hostages in return for compliance in Detroit. After capturing Detroit, Isaac Hull left Henry Procter in command of Detroit; Procter offered Woodward a position as secretary of the territory. This put Woodward in an exceedingly perilous position, since accepting a position under a foreign government was tantamount to treason. Woodward immediately acted—by firing off letter after letter to Washington proclaiming his innocence and insisting that he was merely acting as a necessary intermediary for the beleaguered citizens of Detroit.

Beleaguered they definitely were. Procter's rule was vicious, tyrannical and dangerous. He did nothing to stop British Native American allies from plundering settlements and attacking stray citizens. Woodward, caught between a rock and a hard place, did what he could to intercede, and his conduct during this fraught time was lauded by Detroiters. Woodward organized private funds to ransom hostages from the frequent raids across Michigan. He secured housing for the refugees of the attack on Fort Dearborn and arranged for the safe transport of the survivors of the terrible River Raisin Massacre of January 1813 at his beloved Frenchtown. The massacre, in which 397 Kentucky militiamen, women and children were slaughtered because Procter refused to follow the accepted rules of warfare, proved a pivotal rallying point for the later recapture of Detroit.

In the eyes of Detroiters, for the brief period of British occupation, Woodward served as a vital intermediary and organizer. His habit of composing lengthy and impassioned entreaties to Congress served the city well during this time, as his letters eventually secured aid in the form of food and clothing, as well as military reinforcements that would later reclaim the city. Just before the River Raisin battle, Woodward had intended to set out for Washington to defend his reputation against rumors of treason and collusion with the enemy. A party of Detroiters sent along to Congress an impassioned testimonial to Woodward's great works in Detroit and begged him to remain. He did, but not for long.

The River Raisin Battlefield, which prompted cries of "Remember the Raisin!" *Library and Archives of Canada.*

During the British occupation of Detroit, Woodward suspended all legal hearings, fearing that holding court would muddy his defense against charges of consorting with the enemy. Before too long, his conflict with Procter proved so untenable that he simply refused to follow any of Procter's decrees. He went so far as to defend Whitmore Knaggs, his onetime pugilistic enemy, against the serious charge of bearing arms in defiance of the terms of surrender. Knaggs, Woodward argued successfully, had every right to carry a gun in defense of his family, since Procter was allowing unlawful attacks and robbery by his troops and their native allies.

Finally, by the spring of 1813, Woodward was granted permission to travel to Washington, D.C., to explain the situation in Detroit. By this point, his attempts to stop Procter's atrocities were having no effect, and the East Coast papers were lambasting Woodward for his part in the capitulation of the town. He published a detailed account of the events at Frenchtown and the River Raisin in several newspapers. Woodward's signature passionate rhetoric in this case earned him and Detroit national sympathy, and "Remember the Raisin!" became a rallying cry for the rest of the war.

Woodward then spent a year and a half dallying in Washington, visiting with Jefferson and diving into libraries to craft a newfangled system for a university in Michigan. By the time he returned to Detroit, an exasperated President Madison had appointed Lewis Cass as governor

of Michigan and ordered Cass to clean up the disastrous situation there. Woodward found the inhabitants of Frenchtown so impoverished that they were reduced to eating boiled hay; his letters entreating Congress for more supplies went unheeded.

Woodward's brief tenure as the hero of Detroit was short-lived. By 1817, he was back to his dreamy and impractical self, and he had a new project to replace his failed grand scheme for city planning, which was put to rest by Cass that same year. Now all Woodward could think of was the Catholepistemiad, or University of Michigania. From an early age, Woodward had been obsessed with the concept of classifying every aspect of human knowledge and categorizing each and every bit of information possible into specific branches. This resulted in a plan as simultaneously detailed and abstract as his street plan—and equally practical. Woodward coined new words based on obscure Greek roots to divide the school plan into thirteen departments, or *didaxiim*, all overseen by the universal science of *catholepistimia*.

More than just a university, the Catholepistemiad was to encompass the administration of schools, museums, libraries, research labs, botanical gardens and nearly every aspect of civic and intellectual life. For a city barely able to scrape together enough food for the winter, the concept was ludicrous. Woodward was widely ridiculed and again labeled an absurd intellectual pedant with no regard for the necessities of daily living. The Catholepistemiad was soon re-labeled the University of Michigan.

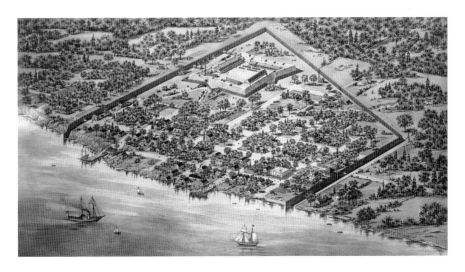

Detroit in 1819, as rendered in the twentieth century. *Library and Archives of Canada.*

Its cornerstone was laid on September 24, 1817, although it would take generations and a move to Ann Arbor before it gained prominence as anything other than a backwater school.

Again and again, Woodward demonstrated to the people of Michigan that his eccentricities outweighed his genius, at least in a territorial setting. As American expansion west drastically increased after the conclusion of the War of 1812, Woodward became increasingly an obsolete figure for bemused sympathy or outright ridicule. When Congress finally allowed representative elections to be held in 1819, Woodward tossed his hat into the race. He was soundly beaten by William Woodbridge, crony of the powerful Cass. Within the year, though, Woodbridge (much like Woodward in his earlier stint in Washington's city council) found the position distasteful and resigned. Cass called for a special election. Woodward again ran for the office, this time using his clout on the bench to campaign. Despite this, Woodward lost yet again, this time to Solomon Sibley. He challenged the ballot count at Michilimackinac, but the recount confirmed Sibley's win.

In 1824, Congress abolished the old system of appointed governors and judges and replaced it with an elective system. The same year, the Detroit Bar Association published a denunciation of Woodward, claiming his "entire want of practical knowledge coupled with habits unbecoming his station" made him unfit for duty. The group deemed Woodward "destitute of honor, probity and respect for established law" and charged him with intemperance after an incident in which he stumbled into a court hearing and needed to be propped up by his assistant while he ascended the bench. Woodward defended himself by claiming that his behavior on this occasion was the result of a powerful combination of medications he was taking for a cold. By this time, however, the point was essentially moot, as Woodward had become a symbol of an antiquated system of provincial behavior that had no place in the growing American frontier town of Detroit.

Removed from the list of appointed judges in 1824 by President Monroe, Woodward lobbied for a diplomatic position in Latin America. He was flatly denied the post by a wise Congress that knew better than to appoint Woodward to any post requiring diplomacy. Yet here again, the fickle citizens of Detroit surprised the nation, deciding that now he was leaving, Woodward was a great man to be celebrated. In February 1824, they held a lavish tribute to Woodward at Ben Woodworth's hotel, and encomiums piled up in praise of Woodward's erudite character and noble leadership in Detroit's darkest times. Some of these praises made their way to Washington.

That same year, Woodward was appointed a territorial judge in Florida. He arrived in October, and his flamboyantly odd behavior and mannerisms charmed the citizens of Tallahassee. It was a frontier town much like the one Woodward had arrived at in 1805, filled with colorful characters and rough French and Spanish settlers who knew how to throw a good party. There he buried himself in his botanical studies and immersed himself in social life with the prominent settlers; he occasionally ruled on a minor court case. After just a few years in Florida, he contracted an unspecified disease from the damp and unfamiliar climate. Augustus Elias Brevoort Woodward passed away at age fifty-two on June 12, 1827.

Later generations would recognize that his lofty and impractical plans, had Detroit had the budget and the manpower to achieve them, might have forestalled several significant problems that cropped up. Although he left no descendants and no monuments other than a road that bears his name, Woodward's bizarre deportment and his influence in the shaping of Detroit's formative years ensured his memory would continue to this day.

4

WILLIAM HULL

Craven Commander

The man responsible for the shameful surrender of Detroit—the only major American city to surrender to an invading force—probably shouldn't have been there in the first place. Ill-suited to the job, long past his prime as a military commander, and already facing charges of incompetence and cowardice, William Hull was at the wrong place at most definitely the wrong time. History has recorded him as a preposterously cowardly old fool, gibbering behind closed doors while his valiant troops chafed at his refusal to face his enemies. The real story is a bit more complex. Although Hull was certainly no dashing hero and was at the least an indecisive and petty governor, recent examinations into his conduct during the War of 1812 have revealed a more nuanced picture of one of Detroit's most reviled villains.

William Hull was born on June 24, 1753, in the colonial town of Derby, Connecticut, just outside of New Haven. Hull's father, Joseph Hull III, was a wealthy landowner, and his mother, Eliza Clark Hull, could trace her lineage back to the *Mayflower*. William attended Yale Law School, where he was roommates with a young man named Nathan Hale. After he graduated, Hull practiced law in Litchfield, Connecticut, until the turmoil of the Revolutionary War. Hull enlisted in the war and fought in at least eight battles, earning distinctions for bravery in four of those conflicts. One anecdote from the time offers some insight into another side of Hull's character, however. When Hale told his friend that he intended to head behind enemy lines in order to spy on British troop formations, Hull tried to talk him out of it,

telling Hale that no one respected a failed spy. Hale persisted and was caught by the British, which led him to utter the famously heroic sentence, "I only regret that I have but one life to lose for my country."[24]

After the Revolutionary War, Hull settled in Newton, Massachusetts, the home of his wealthy wife. He was sent on two diplomatic missions after the war to negotiate terms of peace with British deputies, but both were unsuccessful. Hull practiced law in Newton for many years and led a quiet life. He was appointed a judge and later elected to the Massachusetts State Senate, with which he served until 1805. That year, President Thomas Jefferson appointed Hull as the territorial governor of the new Territory of Michigan. At this time, Hull was fifty-two years old—hardly the ideal choice for a lengthy journey through the wilderness to a wild frontier outpost. Jefferson may have seen little choice in the appointment, though, since many of the ambitious, power-hungry young men preferred to stay closer to the seat of government.

Hull brought his wife along with his adult son and daughter to his new posting in Michigan, arriving in Detroit on July 1, 1805, just a day after Augustus Woodward. Following the June 11 fire, Detroit was a scene of devastation. Woodward and Hull didn't help matters by immediately engaging in a power struggle to the detriment of the citizens of Detroit, pulling their underlings into petty political intrigues. While Woodward was busy snatching up property, Hull, in charge of military operations in Detroit, focused on the minutia of his soldiers' uniforms. At a time when Detroiters could barely find enough scraps of clothing to make it through the winter, Hull insisted on elaborate trappings for the uniforms of his men. Privates were to be clothed in white pants and vests, long black wool coats with large white buttons and tidy red-and-black hats adorned with feathers. His officers' uniforms were to be even more extravagant: the same glaring-white vest and pants along with garishly dyed red wool capes, silver buttons and epaulets and grand white plumes in their hats.

All in all, the uniforms were more suited to a European royal guard than a loosely organized backwoods militia. There was no way Hull's soldiers could afford to purchase the required uniforms, especially since Hull was the one who controlled the sale of these trappings at the territorial trading post. When most of Hull's forces flat-out refused to participate in the absurd display and outrageous expenditure, Hull promptly had them arrested and court-martialed. Other soldiers declined to participate in the frequent military parades, being too busy trying to rebuild their farms. When Territorial Secretary Stanley Griswold intervened on behalf of the

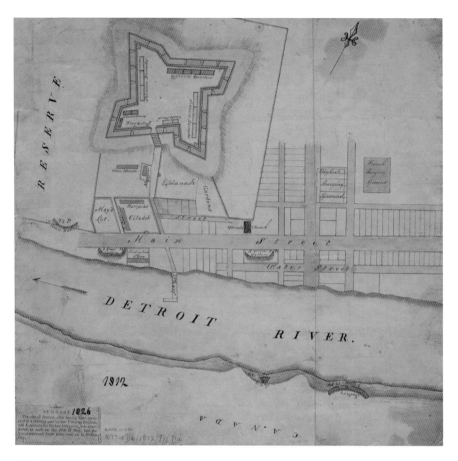

Map of the fort and river in Detroit, 1812. *Burton Historical Collection.*

soldiers of Fort Detroit, Hull had him arrested for fomenting rebellion and fined him $1,000.

Faced with opposition from Woodward and his crony Griffin in the judicial branch, Hull soon backed down and released Griswold. This established Hull's reputation as an indecisive old man who could be intimidated. As was typical of Detroit at the turn of the nineteenth century, Woodward and the other complainants (Campau among them) sought a solution to the problem via incessant petitions and complaints to Congress, the vast majority of which were ignored. When the citizens of Detroit proved intractable in their insistence on having a say in the redistribution of their lands after the fire, Woodward and Hull set out separately for the East. Hull took his time coming and going, complaining, "I am now removing with my

family and all my future prospects to the Country—gloomy indeed are those prospects—surrounded by a Savage foe, in the midst of a people, strangers to our language, our customs and manners."[25]

Hull's constituents thought little better of him. Their complaints ranged from the standard abuses of power to Hull's outrageous—and, to his enemies, dangerous—arming of African American troops. An unsigned complaint addressed to President Madison (and therefore no earlier than 1809) accused Hull of upsetting the delicate balance of frontier etiquette, wherein inconvenient laws were assumed by all to be mere suggestions:

> *In Upper Canada, African Slavery has always existed; and the labor of their slaves, is a principle reliance of many families, on both sides, for subsistence. Mr. Hull has much countenanced the run-aways in that Province, by embodying them into a military company, and supplying them with arms from the public stores. He has signed a written instrument, appointing a black man to the command of this company.*[26]

Overcharging for military uniforms was one thing, it seemed, but to the petitioners in Detroit, arming runaway enslaved people was quite another. There is no recorded response to the complaint.

As his years in Detroit dragged on, Hull faced increasing pressure from warring Native American groups outside the fort. The 1807 Treaty of Detroit gained much of southeast Michigan for white settlers, but it stirred resentment and suspicion of the land-hungry Americans from the Ottawa, Chippewa, Wyandot and Potawatomi. In 1809, the Treaty of Fort Wayne proved the tipping point for the Shawnee brothers Tecumseh and Tenskwatama, known popularly as "The Prophet." The brothers called for a massive gathering of forces from all the area tribes and eventually allied with the British against the American settlers.

Meanwhile, tensions between British and American forces mounted. Incensed by the seizure of American sailors and ships caught between the British and the French, the United States declared war on Great Britain on June 18, 1812. At this point, Hull was on another of his leisurely sojourns in Baltimore and Massachusetts. In March 1812, Congress offered Hull command of the Ohio militia. Hull declined, preferring to stay on as Michigan governor. Congress allowed that Hull could take command of Ohio's militia and still remain governor of Michigan; again, however, he refused. The third time, Congress sweetened the deal: stay governor of Michigan and be promoted to brigadier general, in charge of the

Northwest forces in the coming war. Hull accepted. He was fifty-nine years old.

The deck was stacked against Hull, as he soon discovered. Traveling from Cincinnati through Ohio to gather his forces, Hull encountered a complete lack of discipline in the volunteer forces. He also found them shockingly ill-supplied; many of them lacked any weapons at all, and they had no blankets or powder for the long wilderness march to Detroit. The chain of command within his forces caused conflict from the start. Some troops were volunteers with Kentucky, Michigan or Ohio militias under commanders elected from within their own groups. Other detachments were regular army forces, presided over by officers in Hull's command. Inevitably, power struggles ensued as each man jockeyed for superiority over the others. Lewis Cass loathed Hull from the start, writing to a friend, "He is not our man….[H]e is indecisive and irresolute, leaning for support upon people around him." Cass's resentment soon boiled over and, some historians argue, amounted to mutiny by the end of the war.[27]

When he arrived at Fort Miami just inside Michigan Territory, Hull paused the march and ordered supplies for the final push to Detroit. He also seized on the opportunity afforded by the arrival of a commercial schooner, the *Cuyahoga*. He arranged for the army's heaviest equipment and medical supplies, along with several officers and their wives, to be transported to Detroit on board the schooner. Unbeknownst to Hull, Congress had just declared war, and British military ships prowled the mouth of the Detroit River, eager to snatch unsuspecting American prey. Also unknown to Hull, whether through his own carelessness or his son's, Hull's son Abraham loaded a chest containing the army's payroll and muster records, along with several critical government correspondences, onto the ship. The *Cuyahoga* was captured by the British as it sailed past Fort Malden in Amherstburg. Cass would later use this loss to whip up outrage against Hull for neglect of duty.

By the time he arrived in Spring Wells just southwest of Detroit, Hull had approximately 2,000 to 2,200 men under his command, of which only 450 were trained army regulars. The rest were militia volunteers, barely skilled and poorly armed, with little in the way of discipline. He discovered that in his absence from Detroit, the fort's acting commandant, John Whistler, had been lobbing random shots across the river at Canadian guns to little effect. Hull immediately sent word for Whistler to stop, an action that drew grumbling from his men about his unwillingness to engage the enemy. Instead, Hull convened a council of Native American chiefs active in the area

in an attempt to win them over to the American cause—or at the very least implore them to keep from joining British forces in battle against Detroit.

He was unsuccessful. The influential Ohio Wyandot chief Walks-in-the-Water defected to the British side, taking his men with him, as did Chief Logan Blue Jacket of the Shawnee. Hull was now faced with a dangerous march through British and Native American–occupied territory, towing along unwilling and borderline mutinous militia who could desert at any time. Many of them did.

Faced with the daunting challenges ahead, Hull did not hesitate to fail in pretty much every way possible. On July 10, he ordered a river crossing and attack on Canadian forces. His remaining militia (those who had not yet deserted) was thrilled to finally see some action and proceeded to announce their delight by firing volley after volley of gunfire into the air, thus signaling their intentions to anyone within miles and ruining the surprise of the attack. Hull called it off. Just as they were preparing to cross the river at Belle Isle, over one hundred men stopped in their tracks and refused to get in the boats, claiming (rightly) that their legal duty to the militia stopped at international borders. Hull simply allowed them to wander back to their farms without any repercussions. He did manage to chivvy the rest of his reluctant troops across the river on July 12 and take over the sparsely populated town of Sandwich, which had no military presence whatsoever.

Hull's occupation of Sandwich was more blithering farce than brilliant military maneuver. He immediately issued a proclamation reassuring the townspeople that under no circumstances would any citizen or soldier be harmed during the occupation and that the occupying forces would never take plunder or demand quarter from the inhabitants of the town. He also added at the bottom of the proclamation a note that zero prisoners would be taken. This was to be, he said "a war of extermination" and any white man fighting by the side of a Native American would be killed on sight. This mixed message stirred confusion among the civilians and among Hull's men and did nothing to help his relations with the increasing number of Native Americans allying with the British on both sides of the river. For all the force of his supposed invasion and occupation, Hull's time in Sandwich had no more effect than a several weeks' picnic with a few friends. He sent Cass out on an expeditionary mission, then almost immediately recalled him.

In many ways, Cass's complaints about Hull were valid. In a time requiring decisive action, Hull seemed strangely unwilling to make decisions for the men under his command. The quarrelling between officers of the regular army and those of the militia created an atmosphere

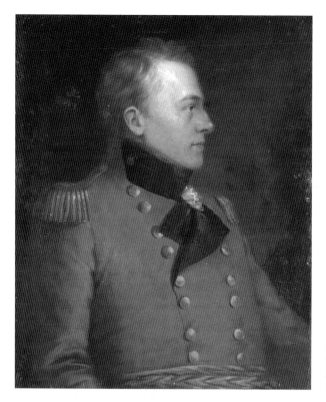

A contemporary portrait of Sir Isaac Brock. *Library and Archives of Canada.*

that—combined with Hull's hands-off attitude—allowed the officers to go their own way with little consequence. Hull had sent Cass to secure a small bridge crossing on an important trail between Sandwich (across the Detroit River from present-day Historic Fort Wayne) and the heavily defended Fort Malden (in present-day Amherstburg) about fourteen miles away. The duties Hull had assigned to him, Cass felt, were beneath his dignity as a military officer. On the scouting party, Cass and his men encountered few British troops, so Cass sent word back to Sandwich asking Hull if Cass should secure the bridge for the American forces as a preface to an attack on Fort Malden. Hull responded that he felt Cass should make his own decision whether to secure the bridge or return to Sandwich, and he had no opinion on the matter.

For a military commander in the middle of an armed invasion, Hull's lackadaisical approach to leadership is remarkable. Cass returned to Sandwich, only to head back to the bridge the next day, meeting Colonel Duncan McArthur along the way on the same mission. The pair joined forces and engaged the British in a back-and-forth struggle over the bridge

for several days. Finally, after losing several men and returning to the bridge to discover the British had brought large artillery guns with them, the Americans abandoned the bridge and retreated to Sandwich, having lost the element of surprise and the advantage than an early attack might have given them.

In the meantime, the supply train attempting to make its way to Hull's army was trapped well downriver of Detroit and surrounded by hostile Native American and British soldiers. Henry Brush, in charge of the supplies, sent word to Hull from Frenchtown requesting a military escort for the crucial supplies. Hull refused. Eventually, his officers persuaded him to send a force of men, but by then it was too little, too late. British colonel Henry Procter had enough time to muster his forces and send them, along with Tecumseh and his men, across the river to intercept the party. Hull lost seventeen men as well as several crucial documents detailing American troop movement and strength. His hesitation had yet again cost lives.

Hull's men were increasingly clamoring for an attack on Fort Malden. He announced that an attack would take place on August 8 but changed his mind when he received word that reinforcements would not be arriving from Niagara as he'd hoped. Instead, he ordered the evacuation of Canada and retreated to Detroit. He then sent a third of his army south in another attempt to reach the supply train. The detachment was ambushed but managed to drive off the British forces. Despite this, the men, under the command of Lieutenant Colonel James Miller, made no attempt to reach Brush and the supplies just a few miles away; instead, they camped where they were for several days and then returned north to Detroit, leaving Brush to fend for himself again.

Incensed, Cass and the other officers penned a letter begging Governor Meigs of Ohio to come to their aid—and to replace Hull. Hull was unfit for command, they said, having given up every opportunity to advance the American advantage.

By now, though, it was too late for Meigs or anyone else to help Detroit. On August 15, 1812, Captain Nathan Heald evacuated Fort Dearborn in Chicago with sixty-five soldiers along with nine women and fifteen children. Instead of turning over the fort's stores, including guns, powder, food and alcohol, as was the usual custom, Heald set them afire before leaving. This angered his Miami allies, who deserted and joined forces with an attacking band of Potawatomi. They killed many of the soldiers and twelve of the children, taking the rest captive. Heald surrendered and was handed over to the British, who had by now taken over Fort Mackinac.

The surrender of Fort Dearborn and the subsequent massacre might have prompted Hull's surrender of Detroit. *Burton Historical Collection.*

When Hull received word of the massacre at Fort Dearborn, he became convinced that the same would happen should Detroit fall to invading forces. That same morning, Major General Isaac Brock's emissary informed Hull that Brock would not be able to, nor would he choose to, control his Native American allies in the future. Hull and the rest of Detroit had heard the exuberant war council and celebratory gunfire between Brock and Tecumseh on the island of Bois Blanc the night before. By 4:00 p.m., British guns along the riverfront were lobbing cannonballs across the river, to little physical effect. The psychological damage was considerable. Hull, cut off from a third of his forces and his supplies by an equal number of Native American troops, refused the entreaties of his officers to return fire on the British. A curious flaw in Woodward's redesign of the Detroit city plan here showed itself to be a devastating mistake: the fort itself, situated at the top of a small rise, could not fire across the river into Canada without inevitably loosing stray cannonballs on the stores, warehouses and homes clustered along the banks. Any attempt by Hull to fire across the river from the fort would strike his own townspeople as well. He shut himself up in his rooms with his son and a few close confidants.

According to historian Robert Ross, "[H]is men could not decide whether he had become an imbecile or a traitor."[28] Panicked Detroiters

began streaming into the safety of the fort's walls when word arrived that Brock had crossed the river at Spring Wells at dawn on August 16. Hull's inaction until then had placed the town in a downright dangerous situation. Cass and McArthur were somewhere south of the fort and might or might not be aware of Brock's crossing. They might also have been unwilling to help a commander they deemed cowardly or a traitor; if Hull surrendered, as seemed inevitable at this point, they might have thought it best for their careers and their reputations to stay well away from the whole matter.

At 10:00 a.m., without consulting any of his officers, Hull ordered the white flag of truce flown over the fort. He also sent his son Abraham across the river to negotiate terms, despite the fact that Brock was already well within sight of the fort on the American side. At noon on August 16, 1812, the American regular armed forces inside the fort surrendered their arms and marched out. Many of the militia immediately deserted, leaving the surrounding settlements open to attack by Brock's Native American allies.

Brock immediately turned the management of Detroit over to Henry Procter, who allowed his allies to attack and plunder at will. For many months, the citizens of Detroit and the vicinity suffered outrage after outrage, culminating in the January 1813 River Raisin Massacre, in which over seven hundred militiamen and civilians were killed while Procter stood by. The survivors were taken to Amherstburg and crammed into an open pen without food or blankets until the townspeople took pity on them and provided supplies. Procter's actions infuriated the people of Detroit, including Father Gabriel Richard, who fired off many heated letters and refused to swear an oath of fealty to the British government. Eventually, in order to secure some sort of protection for the people of Detroit, Richard agreed to an oath swearing that he would not criticize Procter in public, although his journals and letters east prove that he still had plenty to

Artist's depiction, William Hull. *Burton Historical Collection.*

say in private. Procter's poor conduct reached such a low that even his ally Tecumseh publicly castigated him, calling Procter unfit to command.

The tides of battle eventually washed the conflict back toward the east, and as Procter retreated, Tecumseh, although forced to honor his agreement to protect Procter, called him "a fat animal which slinks away with its tail between its legs." Finally, at the Battle of the Thames, many of Procter's men fled the scene of battle, and the rest surrendered. Tecumseh and his allies were the only forces to engage the Americans. Tecumseh was killed, and Procter fled with the rest of his men. He was later court-martialed and relieved of duty, and the findings of the court were read to every regiment in the army.

On September 30, 1813, William Henry Harrison's forces retook the city of Detroit. They found its citizens much changed, in dire straits after months of robbery and plunder. Lewis Cass was appointed governor to replace Hull. As for Hull, after being paroled and returning to Newton, Massachusetts, he was court-martialed in early 1813. The trial was delayed for nearly a year before resuming in early 1814. On March 25, 1814, William Hull was convicted of three counts of cowardice and five counts of neglect of duty. He was sentenced to be shot, but in honor of his service during the American Revolution, President Madison commuted that sentence and Hull was permitted to retire to Newton.

Hull spent the rest of his life defending his actions in the surrender of Detroit, penning two books explaining the circumstances. Recent historians have bolstered this defense, citing the fraught tensions with Native American tribes, Hull's fears for the safety of Detroiters should the fort be taken by force and his uncertainty over where his forces were, as well as how many men Brock commanded. In this matter, at least, history has not yet fully decided. Hull did manage to redeem some of his reputation before his death, being feted with a dinner in Boston and a visit from the Marquis de Lafayette, who sympathized with Hull's travails. Hull died several months after Lafayette's visit, on November 29, 1825.

DANIEL J. CAMPAU JR.

Merchant Prince of Horsemen

Born into wealth and prestige as the scion of one of Detroit's oldest families, Daniel J. Campau Jr. strode through life with a fierce determination and an air of utter superiority. He tightly grasped every shred of his political and social power and fearlessly waded into battle to defend his privilege. He cared little what others thought of him, seeing most people around him as simply too far beneath him to bother. He rarely learned names and made a show of pretending not to recognize men of lesser status whom he had met many times before. Despite—or maybe because of—his unpopularity and rigid demeanor, Campau managed to bring respectability and popularity to one of Detroit's favorite age-old pastimes.

Campau's contemporaries held him in respect—but at a distance. "If you can't say something nice, then don't say anything at all" seems to be the accepted approach to Campau. Nearly two centuries of Detroit mercantile royalty allowed Campau to do what pleased him with his time and money. What pleased him most, and what made the steely-eyed merchant at least a bit more human, was horses. He spent much of his life and not a little of his fortune on this passion, and it would come to define how he saw the world and how others saw him, for good or bad.

Daniel Joseph Campau Jr. was born on August 20, 1852. His grandfather Joseph left a massive fortune from real estate holdings and schemes to his many heirs, who carried on the fine Campau tradition of squabbling over property rights even before his death and continued right through until

1876. Daniel Junior, known to all as D.J., was rewarded the lion's share of the valuable Lafferty Farm property on the east side of the city in what was then Hamtramck. His settlement of $150,000 was more than enough to give him a solid head start on life. Campau was eleven years old when his grandfather Joseph died, and the elder's influence on D.J. was evident in his impeccable attire and reserved manner, as well as his frequent use of French in personal correspondence, an echo of a far earlier time.

D.J. Campau was a trim, somewhat short man with deep-set, steely eyes and a strong chin. He dressed fashionably but not ostentatiously with a high starched collar and sturdy black overcoat most days. His high forehead and trim mustache bespoke elegance of breeding, as did the carnation he always wore tucked into his buttonhole. His voice, a deep, husky rasp, was compelling, and on the rare occasions when he raised it, it made a distinct impression. For the most part, though, he remained icy cold and aloof.

Like many of the men in his family, Campau attended school in New York at Fordham University and earned a law degree. In short time, he was back in Detroit snatching up property and embroiling himself in a series of lawsuits. Campau took his legacy as defender of the Campau properties as seriously as he did his commitment to gentlemanly pursuits. Active in every private club the city had to offer, Campau frequently dined out and indulged in a passion for the sporting life, as it was called then.

In 1879, the same year he passed the bar in Michigan, Campau joined with several of the area's elites to form the Detroit Jockey Club. Horse racing had been going on in Detroit since the French settled there, if not even before. During the town's earliest years, traders and trappers would race their ponies down the frozen river from Grosse Pointe to the River Rouge while riotous crowds cheered them on from shore. In his brief stint as an officer posted at Fort Wayne, future president Ulysses Grant was known for his prowess and daring as a racer along Fort Street. By 1932, Detroit's first dedicated horse track was running at Jefferson and Van Dyke. Known as the Hamtramck racetrack (much of the east side was then Hamtramck Township), the track was overseen by a stern Methodist named James Burns, who might not have gambled but was certainly happy to collect on the betting fees at his popular, rough-and-tumble track.

Before the Detroit Jockey Club, horse racing was a raucous, dangerous and often crime-riddled affair. The two main types of racing were Thoroughbred racing and harness racing, both swift and dangerous occupations. At the Hamtramck track, crowds of day laborers and dockworkers rubbed

THE PACING KING, **HAL POINTER,** BY BROWN HAL,
Driven by Ed. Geers at Terre Haute, Ind., Oct. 9, 1890, Paced three heats in 2:09¼–2:12¾–2:13. RECORD 2:09¼.

Harness racing in the late nineteenth century was a popular but dangerous sport. *Library of Congress.*

shoulders with wealthy young scamps. The smell of fried fish and strong coffee permeated the air, mixed with a dollop of horse manure and the sweeter scent of marsh grass coming in from the river.

The jockeys were reckless, wild young men who scoffed at the danger and risked everything to win big prizes. And they did, often enough. Many of the jockeys in the early days of racing in Detroit and elsewhere were black—free men of color in Detroit and enslaved men in the South. Until the turn of the twentieth century brought oppressive Jim Crow laws, the black jockeys of Detroit ruled the track, and their escapades were much commented on in the sporting papers. Edward D. Brown, known as "Brown Dick," was born into slavery but after the Civil War went on to be one of the richest racers in the world. He was known to carry a bankroll of $75,000 with him, and by the time of his death in 1906, Brown was not only a retired jockey but also an eminent owner and trainer of Thoroughbreds.[29] By the early 1900s, though, stricter segregation and professional jealousy from white jockeys brought an end to the reign of black jockeys in horse racing.

Location of the Grosse Pointe Racetrack.
Detroit Forum.

At the Hamtramck track, races were pretty evenly divided between Thoroughbred runs and harness races. They were loosely organized, and fights frequently broke out over the legitimacy of bets and accusations of cheating by trainers and owners. It was no place for a cultured gentleman or lady, and although young swells and "slumming parties" of upper middle-class people visited occasionally, it became evident that if horse racing were to be elevated in the city of Detroit, a strong hand would be needed to rein in the excesses.

Enter Daniel Joseph Campau Jr. Together with other industry and social leaders—many of whom he would bitterly antagonize over the course of his life—Campau formed the Detroit Jockey Club, with himself as secretary and George Hendrie as chairman. Hendrie was a Scottish-born railroad man who came to Detroit and built an empire of horse-drawn streetcars. Under Campau and Hendrie's stewardship, the Hamtramck track soon became a popular destination for the well-heeled, with steam ferries leaving downtown on the hour every weekend morning and every fifteen minutes in the afternoon. Four races were held every day, and soon a club stand and ladies' stands emerged. Brass bands played between racing sets to entertain the crowds.

By the early 1880s, the old Hamtramck track was too small and outdated. Plans were made for a grand new track and club. In the meantime, however, Campau had not been whiling away his time watching the horses. A gentleman dedicated to the genteel old ways, Campau loathed newfangled modern conveniences with an almost comical crotchetiness, considering his youth. He had grown up taking his smart pony traps and carriages through the city streets, and the intrusion of a crop of new streetcar lines dedicated to bringing Detroiters from here to there with ease was an affront to his tastes. In a strongly worded 1880 letter to the editor of the *Detroit Free Press*, the twenty-eight-year-old Campau reminisced about the good old days and railed against the new evil:

William Livingstone, a Grosse Pointe neighbor of Campau, and his horse. *Library of Congress*.

Even the occasional blast of the ragman's horn, the jingle of the knife-grinder's bell, the melancholy music of the blind fiddler or the deaf accordionist, or worse still, the agonizing strains of numerous hurdy-gurdies, all together, are mild afflictions in comparison with the everlasting clatter of street cars. I have waited some time for others to offer these hints for the abatement of an evil that is growing more and more intolerable every day.[30]

The owner, incidentally, of the several street railways on Campau's side of town was none other than Detroit Jockey Club chairman George Hendrie. Hendrie owned the monopoly on all the streetcars, toll roads and railways from Detroit to the east side but did little to maintain them. Hazen Pingree, Detroit's sainted mayor, dragged Hendrie in the courts and the press for charging exorbitant amounts. One *Free Press* article noted that "the objectionable term 'greedy' as applied to his corporation is eminently proper; and further, that an attempt has been made to mislead and bamboozle the public."[31] Acrimony soon grew between them, which

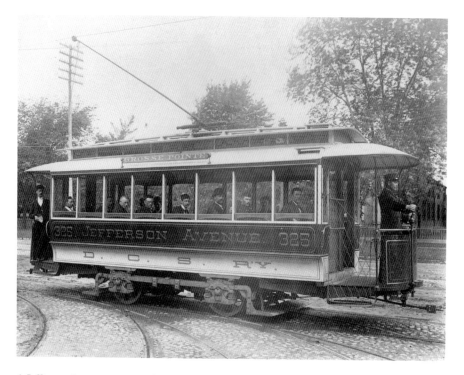

A Jefferson Avenue streetcar similar to the ones that plagued Campau throughout his life. *Burton Historical Collection.*

would eventually lead to a bitter falling-out splitting Detroit's racing set into factions, then into smaller factions. Lawsuits, inevitable when Campau was around, piled up over the years, but not before Campau had elevated the sport of horse racing in Detroit to national prominence and built himself an unparalleled real estate empire.

In 1883, Campau finished construction on an elegant new building in the heart of the financial district at Griswold and Larned, known as the Campau Block. It housed banks and law and real estate offices. It was also the site of several more of Campau's legal scuffles. Campau was as domineering a landlord as he was a track manager, and his stinginess prompted complaints that despite the outward splendor of the six-story building, the Campau Block had cut too many construction corners. When he declined to add fire escapes to the south side of the building, a warrant was issued for his arrest, and despite his cries of blackmail, Campau was found guilty. On another occasion, one of the many Campau cousins employed in his enterprises was tossed out of the offices of the National

The Campau Block in Detroit's financial district. *Burton Historical Collection.*

Film Company after trying to toss out flammable film canisters. Another elderly tenant died as a result of injuries sustained when an elevator lurched upward while he was trying to enter it.

Despite these setbacks, Campau prospered; the sum of the lost lawsuits couldn't touch the interest on his vast real estate wealth. And while he was building his capital, Campau also tended to his political prestige. In 1884, he was named as Michigan's delegate to the Democratic National Convention in Chicago, where he spearheaded efforts to elect Grover T. Cleveland as president. Campau's forceful personality and wealth made him a natural influencer in local and national political circles and earned him a post as the U.S. customs collector for Detroit for several years.

In 1884, Campau parlayed his prestige and wealth into the formation of the Detroit Driving Club, an extension of the old Detroit Jockey Club. Convincing the city's elite to pony up subscriptions of $1,000 or more, Campau announced grand plans for the club's facilities, which were by now outgrowing their half-mile track and in need of substantial enlargement. But his highhandedness alienated many club members, and rumblings of misuse of club funds stirred at the lower levels. In 1889, a group of investors called a special meeting. There, they accused Campau of treating the club as his own private fiefdom. He had, they said, "usurped all the powers of the association and continuously antagonized the board of directors."[32] His opponents alleged that Campau refused to call board meetings and instead made all decisions himself. Campau contended that he was the only one who got anything done, and that further, every time he did call a meeting, no one showed up. Campau used the club's secretary as his personal manservant, they said, conducting Campau real estate deals on club time. Campau insisted that what was good for his holdings was good for the club, as it was his skilled management that allowed him to lead the Driving Club. After a stormy session, the accusers backed down, although Campau did acquiesce to giving up complete control of the club's bank accounts.

The 1889 scuffle was typical of Campau's dealings: stride in, grasp control and hold on tight until the tiniest portion was wrested from his hands. An account in *Harness Horse Magazine* described him thus:

> *For Campau was built that way. He proposed to run everything with which he was connected or make life miserable for those who "beat him to it." He was one of the stormiest of human storm-centers, the barometrical reading in his vicinity being as a rule at a record low.*[33]

Watching horse racing was a popular pastime for Detroiters. *Burton Historical Collection.*

Despite the storms of controversy, or perhaps because of them, Campau managed to impose his iron will on his peers for long enough to build a grand new concourse and facilities for the Detroit Driving Club at Jefferson and Algonquin in 1894, just a few blocks from the old Hamtramck (now Grosse Pointe) facilities, on land he owned but sold to the club. The new Detroit Driving Club boasted every amenity available: a five-thousand-seat covered grandstand with separate accommodations for the ladies; seventeen horse barns with space for twenty-five horses each; an electric powerhouse; a caretaker's cottage; a home for the club secretary; a private dock for yachts; and a grand three-story Victorian clubhouse fitted with the latest in comfort and novelty. A remnant of the sweeping entrance at the corner of Jefferson and Algonquin can still be found in the brick-paved block.

The inaugural race at the new Detroit Driving Club was held on July 16, 1894. More than eight thousand people attended the festivities, and the horses thundered down the track to rapturous applause. A jubilant *Free Press* declared:

> *There is to-day no trotting track in the country which compares in completeness with the one owned by the Detroit Driving Club. The stand is the finest, the track is the best staple of engineering skill and the stables would discount anything in the line. People would gaze down that stretch in amazement yesterday, and look at the grand stand with bewildered expressions on their faces. Everything combined to make the event beyond their expectations, and the assembled thousands were lavish in their praises of the enterprise of the club.*[34]

The presence of the city's elites, representing the oldest and wealthiest families, as well as the smartly dressed women fitted out in finery that would rival the fashions of the East Coast, added to the festive atmosphere that July day, and a torrential downpour barely dampened the joyous mood.

Campau's new track—and his willingness to seed the highest-paying race prizes in the country—soon brought the Detroit Driving Club to national prestige. He had the first pick on deciding when the meetings, or series of races, would be run. For a time, the premier event in harness racing in the country was the first running at the Detroit Driving Club. But Campau had made powerful enemies and stretched the club's finances dangerously thin. The same year that the Detroit Driving Club opened, George Hendrie took his fortune and his faction up to Highland Park and established the Detroit Gentlemen's Driving Club west of Woodward and just shy of Six Mile Road. The two tracks were far apart, but disagreements over the hotly contested racing calendar consumed the attention of Detroit's racing set. In the days before automobile-driven horse trailers, arranging logistics for the transportation of highly valuable and delicate horses meant that scheduling national races often boiled down to the will of whoever shouted loudest.

Campau was never a shouter, but he often arranged the schedule to his benefit in a quieter but equally effective manner. At the annual national meeting of harness racing club leaders, Campau would first select the men whose opinions he thought were most important. Renting a private room for lunch after the morning's contentious debates, he plied these men with copious amounts of champagne until they proved malleable; shortly after the committees reconvened, a surprising number voted in favor of hosting the year's first event in Detroit.

All this wheeling and dealing, though, required vast amounts of money. He may have been stingy, overbearing and litigious, but Campau also ran a scrupulously honest racetrack. In an era of side dealings and rigged races, Campau's were the most law-abiding in the country. This prevented cheating, but it also kept the club from raking in the kind of extra cash that other clubs in the country got by on. Just a year after opening, the Detroit Driving Club's directors, including Campau, took out a large loan on the property. That same year, Campau took out a separate mortgage for $55,000 to add to the operating funds for the club. In 1898, the club defaulted on the interest payments to Peoples Savings Bank, and the bank began foreclosure proceedings. Campau and several others paid their portion of the loan, $6,000 each, and sued the Detroit Driving Club entity for repayment.

Savvy lawyer that he was, Campau worked the system for several years to keep the club running. The club did not contest the 1898 suit by Campau, Vail and Palms; instead, Campau was appointed receiver, and the debt was sold to him. But the other club directors proved less willing to accept such a loss, and they sued to stall the sale of the club and its debts. The case went

back and forth for almost nine years; meanwhile, the Detroit Driving Club continued to enthrall racing enthusiasts, and Campau continued to dole out huge cash prizes for winning racers.

He had other things to focus on as well: by the turn of the century, electric streetcars and automobiles were changing the landscape of Detroit more rapidly than the even young Campau had predicted back in 1880 when he complained of the evils of the streetcars. Acceding to pressure from wealthy club members, management allowed automobiles to race on the track for a brief time. On October 10, 1901, Henry Ford celebrated a victory over Alexander Winton, skyrocketing him—and his automobile—to fame and fortune. Altogether, though, auto racing didn't last long at the Detroit Driving Club. With the exception of a few novelty races, the track was soon reconverted to a horse-only property, at least for a few more years.

Campau's city was changing, and he was having a hard time keeping up. His beloved property, once in Hamtramck Township, then in the fleeting city of Fairview, was in danger of being gobbled up by Grosse Pointe and Detroit.[35] Detroit's sprawl eastward was aided by Campau's old rival, George Hendrie, and his Detroit Citizens Railway and Detroit United Railway. Oddly enough, though, Hendrie was an unlikely (and rather unwilling) ally

The Detroit Driving Club hosted several auto races in the early days of cars. *Library of Congress.*

in Campau's fight to save Fairview from annexation. If Detroit and Grosse Pointe swallowed up the tiny village, Hendrie's streetcars could no longer claim extra fares from riders traveling outside the city limits and must instead allow passengers to ride straight through his territory. Campau and the Detroit United Railway joined forces and took the fight against annexation to the mayor's office, to the state legislature and eventually to the Michigan Supreme Court, but to no avail. In 1907, first the City of Grosse Pointe Park to the east and then the City of Detroit annexed the remains of Fairview, and Campau was left to bicker with the City of Detroit over his property rights and against the drainage of Conner Creek on his land.

That same year, Campau had swallowed another bitter pill. The Detroit Driving Club's finances were in such a mess that in 1906, no races were held. D.J. Campau retired from the leadership of the club, and the organization's debt was sold to a corporation from St. Louis. In February 1907, the courts delivered the final ruling on the distribution of income and debts. Campau lost not only his small portion of the race winnings from the club's final year but also the original $55,000 mortgage he had taken on the land to finance the move. The contents of the Detroit Driving Club were eventually auctioned off in 1910, although the proceeds did not cover the losses of

A transitional time for racing fans. *Library of Congress.*

the club. The track served as the testing grounds for the short-lived Chalmers Motor Company before being unceremoniously paved over to make way for housing developments. Harness racing continued at George Hendrie's Highland Park track and at the new Michigan State Fairgrounds.

To add insult to the string of personal injuries that occurred in 1907, on June 21, Campau's house burned to the ground. He had recently spent tens of thousands of dollars to move it to a new location on his property and was conducting extensive renovations. When the fire broke out, it was rather small. Before long, though, it raged throughout the building because

there was no accessible fire hydrant. Ironically, one of the reasons that the City of Detroit had annexed Fairview was due to residents' complaints about lack of city services in Fairview—including firefighting equipment. Detroit firefighters took a long time to arrive at the scene, and their attempts to siphon water from Conner Creek were stymied by the layers of muck that clogged the creek. Had the Fairview annexation occurred sooner or the creek been drained, as city officials desired and against which Campau fought for years, his home might have been saved.

The following year dealt another blow to Campau's prestige. After more than twenty years as a prominent representative of Michigan Democrats in national politics, Campau and his so-called Campauites were ousted from the leadership of Michigan's national Democratic committee. The years of Campau's "cold, self-centered, egomaniac conception of life, his universe which consisted solely of D.J. Campau getting what D.J. Campau wanted" were over. As with his ouster at the Detroit Driving Club, rumors of Campau's misuse of funds compounded his tyrannical reputation. Daniel J. Campau was a political dinosaur, and although he still wielded considerable social and financial power, he would never regain his political prestige.

After 1908, Campau retreated from politics, although he continued to breed and race horses. He purchased the esteemed harness racing magazine the *Horseman*, but after its stint as the highest-quality horse magazine in the country, Campau's habit of alienating employees led to the publication's ruin. It was said that he managed to fire six separate editors-in-chief in the span of a single year. In 1917, he sold the *Horseman* for pennies on the dollar to a rival he had earlier refused to recognize at a sporting event.

Campau remained socially active in his later years and was often seen in the company of the city's most eligible young women. One contemporary noted that "more than one woman had loved him to her sorrow; but that he ever loved anybody, man or woman, but himself, is doubtful."[36] He took to traveling to New York and established a winter residence there and in a downtown Detroit apartment, even after he completed the renovations on the Conner Creek home. A staunch horseman, he did occasionally dally in the new fad of automobiles. One afternoon in 1913, as he was driving his electric motorcar down Woodward Avenue, he paused at the corner of Grand River Avenue to wait for the traffic officer's signal. As he waited, an oncoming Detroit streetcar experienced a switch failure and, instead of continuing forward as it was supposed to, turned sharply and plowed straight into Campau's car. He was violently thrown from the vehicle, and the streetcar continued forward for seventy feet as pedestrians scattered to

avoid being run over. Campau sustained minor injuries but recovered from his latest battle with the streetcars of Detroit.

An inveterate bachelor, Campau shocked all of Detroit and much of New York's social scene when at the age of seventy-two he married Katherine DeMille Moore, aged sixty-three. Mrs. Moore was the former wife Campau's early business partner George Moore, and she had been living in New York for several years. There certainly must have been a story in their meeting and courtship, but the ever tight-lipped Campau never shared it.

The couple spent a honeymoon motoring through the White Mountains of New Hampshire, then settled into a life of social calls and charitable events. They summered in Detroit and New York and visited Mrs. Campau's family in California during the winter. After only a few years of marriage, Campau contracted a bad cold that developed into pneumonia, and within a week, he died.

Daniel Joseph Campau Jr. died at the age of seventy-four on October 5, 1927. His life and activities were described in detail in the local and national papers but with a remarkable lack of warmth and regret. Very few, it seemed, mourned the passing of Detroit's merchant prince of horses. One chronicler noted, "D.J. Campau was rich, and he was as proud as the Prince of Darkness was fabled to be."[37] He elicited as little sympathy in death as he had granted others in life, and the legacy of his sporting empire faded away under the bustling new metropolis ruled not by the clip-clop of horses but by the rattle of streetcars and the buzz of automobiles.

BILLY BOUSHAW

The Foist of the Foist

*B*illy Boushaw was a barman, first and foremost. Make that *foist*, in the dockside parlance of late nineteenth-century Detroit. Boushaw's humble beginnings, stratospheric rise and eventual slide into poverty and obscurity mirrored the story of Old Detroit as it transitioned from a mid-sized city to a global influencer. Boushaw, beloved by newspapermen and by the dozens of dockside itinerants who made up his clan, parlayed his unique position to rig elections for years. He was the king of the electioneers, and while he could, he made sure that every vote in his district went exactly the way he wanted it. By the end, though, he became a cautionary tale made obsolete by new federal regulations, Prohibition enforcement and a jaded public.

Billy was born into the trade. William O. Bouchard, known as Billy Boushaw all his life, entered the world on February 16, 1863, in his parents' modest home on the corner of Atwater and Hastings Streets. His father and grandfather were saloon-keepers. Many of his uncles and brothers sailed the Great Lakes on shipping vessels then returned to the family headquarters when on furlough. The Boushaws were an old French Detroit family of the type that new American Detroiters mocked for their clannish ways and party-loving lifestyle. As a boy, Billy helped out in the bar and witnessed firsthand the raucous, down-at-the-heels life of Detroit's itinerant sailors and odd-job men. He also became acquainted with the tonier residents of Detroit, attending the Catholic St. Mary's Church school, which still stands at the corner of St. Antoine and Beaubien Streets

in the heart of what is now Greektown. Billy was in one of the first classes held at the school, built in 1869 to accommodate the growing number of German Catholic settlers to the area. His classmates were a mix of new arrivals and kids from the old French families, as well as a few American sons of businessmen and tradesmen.

During summers, Billy took every chance he could to steal down to the swimming hole at the foot of Hastings Street, at what is now Rivard Plaza. There he met boys from all classes and formed lifelong friendships with far wealthier fellows such as John C. Lodge, who later served many years on Detroit's city council and several terms as mayor of the city. Billy happily plied these connections to the rich and powerful, but he was also content to keep his influence under wraps when it suited him. He grew so attached to his swimming hole memories that in 1914, when the Grand Trunk Railway proposed closing the foot of Hastings to erect storage sheds, Billy pleaded with city council to save the swimming hole, saying, "I want it kept for the little fellows, who dive from there as I used to many years ago." Billy's sentimental attachment to the haunts of his childhood lingered throughout his life.

In 1888, having finished school and done his time in the family business, Billy Boushaw opened up his own saloon at the northwest corner of Beaubien and Atwater Streets, just a block from his home. It was a simple, two-story wooden structure with plain wooden plank floors and a corner entrance to entice traffic from the busy cross streets. Inside, though, the place was chock-full of the sort of late Victorian knickknacks that can only be found in a place frequented by travelers:

> *His saloon was a veritable store-house of treasures. In a glass showcase were curios from every corner of the earth, for the floaters as well as the prominent and successful never forgot Billy and usually brought or sent something back if they strayed away from Detroit.*[38]

The Detroit River, 1914. *Burton Historical Collection.*

Later newspaper reports tended to conflate Boushaw's place with the Bucket of Blood; this equally notorious saloon, though, was at Hastings and Clinton Streets in the Black Bottom neighborhood and was owned by Boushaw's political ally "Big Jim" Nevils, a black man and head of Wayne County's municipal janitors.

Contrary to our tendency to romanticize them, most saloons didn't have fanciful names. Billy Boushaw's place was typical in that and many other ways. It was simply Boushaw's place, and the dockhands, sailors and indigents of the area certainly didn't need a fancy sign to tell them they were welcome at Billy's. Boushaw served just one meal a day, usually breakfast, and more often than not he told his visitors to save their pennies and gave away the meals for free. These floaters had no other permanent home, and they looked up to Billy as a provider and paterfamilias. Boushaw's served as dining establishment, bank, social hall and often hostel for the hardworking but poor floaters in the city.

Boushaw's patrons, eager to repay his kindness, frequently asked him his opinion in political matters. It didn't take long for Billy's advice to start

Billy Boushaw's tavern at the corner of Beaubien and Atwater. *Burton Historical Collection.*

making real waves in the chaotic political scene of Gilded Age Detroit. Until 1918, all city-level voting was broken down into regional wards and precincts based on geography. A board of forty-two aldermen oversaw the elections, two from each of the twenty-one wards. As Lodge described the setup, "[I]t was an awful mess. The saloon element dominated the city government until public opinion revolted and demanded an entirely different set-up."[39] Until that time, though, saloon-keepers determined which political candidates got the votes from their patrons.

And Billy was the "Foist of the Foist": the unrivalled king of the first precinct, first ward. The First was the most heavily populated of Detroit's wards, extending from the river between Woodward and Beaubien all the way to the city limits. The First Ward, according to the *Detroit Free Press* in 1908, was "where ex-convicts, thugs, thieves and booze grafters swarm the election booth and rule the day."[40] Holding court over the assembled riffraff, Boushaw decided who was elected to office in his ward, as well as which aldermen and election monitors were chosen to oversee voting. He accomplished this through several methods, some more legal than others.

First, Boushaw adamantly refused to accept cash payments for influencing votes. One naïve candidate's campaign manager learned this the hard way. When he approached Billy currying favor, he offered up a wad of bills, $300 in all. Boushaw asked, "Now what am I supposed to do with this, anyway?" The humbled supplicant suggested that Billy buy his boys a round of drinks, which Billy happily did. Billy also promptly sent the vote in favor of the hapless candidate's opponent. The young man, John Gillespie, learned his lesson, though: by the next election, Gillespie was in charge of the workforce at the water commission and running for office himself. Just days before the election, about forty of Billy's men were laid off with no notice, sent home with word that there were no longer jobs available for them. When he heard about this outrage, Boushaw made his way to see Gillespie. "It's out of my hands, Billy," said Gillespie. "Oh, and by the way, how do you think your precinct's vote is going to head?" Billy got the hint, and every man in his precinct voted for Gillespie. Miraculously, the day after the election, they all had jobs at the water commission again. It wasn't cash Boushaw was after; jobs and influence for his men were the key to gaining the coveted endorsement of the First of the First.

Malcolm Bingay, longtime newsman, was a fervent fan of Boushaw's gentlemen's agreements, finding them acts of charity rather than graft:

Did he not find them work? Did he not feed and shelter them when times were hard? Did he not let them have credit at his bar? They all had a direct personal interest in voting the way Billy asked them to, just as you yourself might vote for a candidate because of a request by a kindly neighbor or benefactor.[41]

On Election Day, Boushaw's saloon and adjoining business at 111 and 115 Atwater Street were bustling. A constant stream of the downtrodden rolled in and out, sometimes emerging with a new outfit or haircut in order to vote again. An army of derelicts marched from polling place to polling place along the riverfront, stopping at each to cast a vote for Billy's candidates. Stationed at each polling spot were Boushaw's trusted advisors, who were ready and willing to assist anyone who might have forgotten how to vote. Voters could ask for assistance in marking their ballots; in Boushaw's territory, around seven of every ten voters requested help marking their ballots from Boushaw's lieutenants. This ensured that, even if someone were to want to vote independent of Billy's choice, the ballot was marked the way he wanted it to go.

The new voting machines took some getting used to. *Library of Congress.*

Inside Boushaw's headquarters, which conveniently also served the official precinct ballot-counting location, participants were adjured to "let the blue bird fly" and "open the graves." The officials in charge of checking the ballots to make sure each mark was placed correctly had small stubby blue pencils palmed or slipped up a sleeve. When it came time to record the ballot, it was easier enough to make a slight correction before the ballot slid into the box for the final time. Opening the graves was equally simple: many dead or missing voters, especially in the itinerant population of the First, were still on the roles as registered voters come election time. It was no problem at all to rustle up a man or two claiming that name, and Boushaw's men were right there to corroborate their identity, regardless of pesky matters like lack of identification or the improper spelling of one's own (supposed) name.

Boushaw's precinct was remarkably crowded on Election Days. The population swelled as sailors returned home, and floaters miraculously were in residence, sometimes at surprising locations. Plenty of Duffys, Malloys and Murphys claimed their permanent residence at Boushaw's and other local watering holes, regardless of whether the saloons offered boarding service or not. In 1912, more than seventy voters declared Boushaw's as their primary residence, although there was barely room for ten men to squeeze into the upper rooms. Other saloons experienced similar crowded living arrangements: Sam Bittles's saloon had fifty registered voters but no living quarters.

Not all the saloonkeepers were thrilled with Boushaw's voter registration practices. John Martin, the proprietor of the Canada Hotel on Brush Street, threatened to sue Boushaw for defamation, insisting that not a single one of the fifty-two voters registered from his place by Billy was a living human being. Another Woodward Avenue saloon manager was appalled by the practice, declaring that "they're floaters and bums, and ought not to have a vote. I think they registered my porter, who is Canadian."[42]

Just a few blocks northeast of Boushaw's precinct was the Third Ward of the Second Precinct, in the "old jail district." Now paved under by I-375, Hastings Street was for many years the bustling center of Detroit's black entertainment community. Here at the Bucket of Blood, Jim Nevils orchestrated gambling rings and cooperated with Boushaw to secure the votes for their chosen candidates. Between them, Nevils and Boushaw held a tight grip on the politics of the city for many years, as Boushaw ran the First and Nevils controlled the "Negro vote." It was said that between them, Billy and Jim knew the outcome of any given contest a year before Election Day.

As Billy voted, so voted his entire ward, generally down to the very last man. In the 1914 gubernatorial election, Boushaw, technically nonpartisan but in reality a staunch Democrat, was able to use his voters to drive a wedge into the Republican primary; at the time, all primaries were nonpartisan. By the time November rolled around, though, his boys cast their votes in favor of the Democrat candidate, save for one confused soul who prompted the *Free Press* to quip, "Lone Osborn Vote Perplexes Durfee: Head of Election Committee Puzzled by Slip in Boushaw's Precinct."[43] Boushaw held a similarly tight rein on the mayor's race, delivering a 2–1 victory overall for Democrat Oscar Marx over Frederick Ingram. In the First, Marx carried 250 votes for Ingram's 6.

Boushaw was a darling of the press, guaranteed to drop a great quote and point a reporter in the direction of a good story—with his approval, of course. He wasn't a particularly talkative man, and his short, stocky figure was more often spotted at the back of the crowd than on stage. He was always obliging and friendly, though, and reporters flocked around him every year come Election Day. One year, this caused a bit of a problem for Boushaw. A political opponent hired a newspaper photographer to station himself at voting locations and take pictures of every voter that stood in line or entered the building. This didn't sit too well with many of Boushaw's voters, who hurriedly left before they could cast a vote. Despite the skittishness of these voters, Boushaw still managed to pull together enough people and deliver the vote in his favor.

On another occasion, a challenger insisted on witnessing the counting of the votes at Boushaw's place, where five election board members were registered and where the official count took place. Boushaw and the election officials dithered and tarried as much as they could, but the man would not leave. Fortunately for them, Billy Boushaw's heavy gold pocket watch was found in the man's pocket. He was arrested and taken to the city jail. Finally, after hours spent declaring his innocence, he was freed on bail. By the time he made it back down to Atwater Street, the votes had all been counted, and Boushaw's candidate had won handily.

Soon enough, though, a frustrated public was insisting that Boushaw and his allies held too much sway in the state's governing. In 1916, Boushaw-backed Oscar Marx won reelection for mayor but by a much narrower margin than the last time. A federal inquiry into voter fraud and a host of other illegal activities essentially tied Boushaw's hands. In what was dubbed "the greatest battle ever fought against corruption and criminal action in Detroit elections," forty election officials were forced to resign. At Boushaw's

115 Atwater, a small outbuilding next to the saloon, fifty-five men were found to have registered the place as their primary residence. Boushaw's response to the allegations was typically tongue-in-cheek:

> *Some of the boys are out sailing the lakes now. Some of them will be back to vote at election. Some of them won't. But Billy Boushaw's is the home they will come to and the home they register from....It's the only home that a lot of them have. When the decks of the ships aren't open to them, Billy Boushaw's place is. They're my boys, and do you think I'd get one of them in trouble?*

Billy was experiencing some registration complications of his own: although officially registered to vote from the saloon, Billy's residential home on Marlborough Avenue was outside of the First. He couldn't even legally vote in the district over which he held so much sway. Sourly, he held back from his customary ceremonial vote, muttering to reporters, "I'm no d——n fool. I know when not to vote."

Despite Boushaw's best efforts, local, federal and private detectives were stationed at the polling places come Election Day 1916. The scene was vastly different from previous years' celebratory debauch. Grim-faced voters and organizers watched helplessly as the incorruptible government agents checked every registration and ballot carefully. Many were unable to vote at all and mulled around in confusion. One board member, Jimmy McDowell, "made several attempts at displaying the old time 'pep'" to rally the men, "but a big boned, broad shouldered policeman…hauled out a little book of instructions and McDowell subsided," according to the *Free Press*.[44]

Another blow to Boushaw's influence came in the form of the forced resignation of Boushaw's old ally, John Gillespie, from his position as chief of police under Mayor Marx. Since their first arrangement years before, Boushaw and Gillespie had always had a gentlemen's agreement on votes and the prosecution of crime in Boushaw's precinct. Now, under charges of corruption and vice, Gillespie tendered a hasty resignation in September 1916. Marx was saved and went on to win in November, but he appointed the multimillionaire James Couzens as his new police chief. Immediately on taking office, Couzens declared a war on vice in the city, shutting down gambling and closing saloons that operated on Sundays.

By 1918, the city's new at-large representation system was in effect. Boushaw, Nevils and their allies no longer held sway; Boushaw couldn't even accurately predict the 1917 school board election. He blamed this on a

A typical saloon interior in Detroit. *Burton Historical Collection.*

number of factors, including the increasing power of women to influence elections. Although they would not be able to vote in state elections until 1919 and national elections until 1920, women were permitted to cast ballots in school board elections. Boushaw was flabbergasted, declaring, "[T]hey vote the way they want, not the way their husbands tell 'em."[45] For the most part, too, these women voted for and influenced the powerful cause of Prohibition in Michigan. Suffrage and Prohibition went hand in hand, and the Woman's Christian Temperance Union held the kind of sway that Boushaw had previously wielded.

In Michigan, Prohibition went into effect at midnight on April 30, 1918. The double blows of Prohibition and election reform hit Boushaw and his business hard. When Prohibition agents raided Boushaw's saloon—ostensibly a near-beer joint—in December 1919, they found only Boushaw and one old man at the place. They did not bother to prosecute. He was arrested in 1926 for having liquor on hand, the first time he had been charged with any offense in thirty-eight years. Billy hadn't lost all of his fight, however. The arresting officer, Lewis Muller, missed the first scheduled hearing because, he said, he was told by an unnamed person that the case had been dismissed, so he didn't bother to show up at court.

When the case was reconvened, Muller admitted that he couldn't be sure that he had actually paid for the beer he was handed. Although it was illegal to buy, sell, manufacture or transport alcohol during Prohibition, there was no law against the consumption of beer or booze. He'd set down a quarter, Muller said, but he just couldn't remember if Boushaw actually picked it up.

Next, Muller muddled the case even further by approaching the presiding judge in his office hours asking him to drop the case, as Boushaw was "a good enough fellow" and Muller didn't want to inconvenience him. By this time, the whole case was so confused that, although Boushaw did go to trial, he was found not guilty. No doubt the jury was moved by the specter of Billy's old influence, combined with a sense of pity for the old man who had by now become so obsolete that he couldn't even avoid arrest for selling a glass of beer.

One final case against Boushaw, in 1932, drew the curtain on his rise and fall. Arrested for selling whiskey to a customer, Billy insisted that the concoction of whiskey and quinine, which turned out to be laughably weak and watered down, was cold medicine. "And if I was selling whiskey," he said, "no one would get it for a quarter a pint." The charges were dropped, and Billy Boushaw faded into obscurity.[46]

By the time he passed away in December 1937, Boushaw's benevolent grip on the doings of the riverfront had long since loosened. His obituary lavished praises on his generosity and his benevolence, and he quietly slipped into legend, a colorful character from a past that Detroit no longer had time for. "The City had already outlived Billy before his death," read his elegy, "and the 'Foist of the Foist' will die with him because it was never so much a precinct as it was a state of mind—and the locale of a big heart that warmed and clothed and fed those who thanked him for his care."[47] His saloon was unceremoniously demolished less than five months later.

WILLIAM COTTER MAYBURY

Not All that Bad, Really

*H*e was gentle, charitable and, above all, conciliatory. Rocking the boat ranked right up there, for him, with being uncheerful on the list of no-nos. The master of the eloquent speech and the glad hand, later derided as an ineffectual and inveterate baby-kisser, William Cotter Maybury lucked into some pretty good connections from birth and cleverly turned those into further political opportunities. He was always willing to give a friend or relative a hand up in business and happy to give a speech at the ladies' club, the country club or the charitable hospital.

So why all the derision for poor William Cotter Maybury? He may not have been a saint, but his later vilification can be attributed to two causes: Hazen S. Pingree, the "Idol of the People," and newspaper writers who disapproved of Maybury's lifestyle. In a time when being a confirmed bachelor was taboo, as was hanging out with others of the same orientation, insinuations of a homosexual lifestyle could destroy a reputation. William Cotter Maybury was in the wrong place at the wrong time, essentially, and he was just too nice to come out of the public scrutiny without some battle scars. Despite all this, his administration—and his connections—had a lasting and permanent effect on the transportation history of Detroit and the rest of the world.

Maybury's birth and childhood were auspicious enough. Born on November 20, 1848, at his parents' home in the recently settled Corktown in Detroit, William Cotter Maybury was the son of an Irish immigrant from County Cork. Despite being born in one of the worst years of the Irish

Famine, Maybury wasn't born into the poverty typical of the recent émigrés. The Maybury family had left Ireland in 1834, well before the famine, and they had more money than most other Corktown settlers. William's father, Thomas, traveled to America with another old Cork family, the Fords. They two families had been close in the old country and set up a new life in American together, settling in Detroit and Dearborn. The three Maybury brothers and the three Ford brothers remained tightly bound all their lives, and this would carry on to their children's generations.

The two families shared a close connection. When William Ford married Mary Litogot on April 25, 1861, in the home of Thomas Maybury, young William Cotter was in attendance. The couple had five children: Henry, Margaret, Jane, William and Robert. As a boy, William Cotter Maybury played in the yard on Lafayette Avenue with a boisterous pack of assorted Ford and Maybury "cousins." Later, William would employ the political machinery of Detroit to give his cousin William Henry Maybury and Henry Ford a leg up in business.

William Cotter Maybury attended high school in Detroit, then headed to the University of Michigan for an undergraduate degree in literature and a law degree in 1871. He showed a real love for literature and writing and practiced his speeches at the university with the debate club and the supper clubs that were common at the time. Returning to Detroit, he set up a law practice, and it wasn't long before his genial nature secured him a job as the Detroit city attorney, a position he held from 1875 to 1880. In 1880, the thirty-two-year-old Maybury ran for the U.S. House of Representatives as a Democrat, but the state elected only Republican candidates.

By 1882, the reputation of the Republican Party was damaged by charges of corruption and nepotism. Maybury ran again and won a seat in the Forty-Eighth Congress, where he served on the influential House Judiciary Committee and Ways and Means Committee. As a member of the Judiciary Committee, Maybury oversaw important petitions and appeals. One of these, from suffragettes Susan B. Anthony and Ida Hayes in 1884, appealed to Congress for the women's right to vote. It was denied. Maybury wrote the majority opinion, in which the committee declared that voting, for women at least, was a privilege and not a right. Citizenship, the committee decided, was no guarantee to voting rights, and besides, what truly genteel woman would ever want to venture outside the home and participate in public voting?

"The great mass of the intelligent, refined and judicious," Maybury's statement declared, "with the becoming modesty of their sex, would shrink from the rude contact of the crowd and, with the exceptions mentioned,

Right: Henry Ford, an old friend of the Maybury family. *Library of Congress.*

Below: Detroit Bi-Centennial Celebration, helmed by William Cotter Maybury. *Detroit Forum.*

leave the ignorant and vile the exclusive right to speak for the gentler sex in public affairs." Woman's sphere, the committee ruled, was the home. The public sphere was reserved for men:

> *To permit the entrance of political contention into the home would be either useless or pernicious—useless, if man and wife agree, and pernicious if they differ.... [T]he peace and contentment of the home would be exchanged for the bedlam of political debate and become the scene of base and demoralizing intrigue.*[48]

With that, Maybury and his brethren in Congress stamped out the question of voting for women. Although some states had already granted women the franchise, national suffrage would not become law for another thirty-five years.

Maybury served in the House from 1883 to 1887. When the time came to announce for reelection, however, he found that despite achieving several wins for Michigan, including acquiring federal funding for the new Belle Isle Bridge and for the postal service in Michigan, his supporters had stirred animosity within the party back home. "With all the dirty and outrageous work done by his supporters in his behalf," the *Free Press* wrote, "he has but a beggarly showing in the list of delegates."[49] With some prodding, Maybury withdrew his name from the race and returned to Detroit to repair his reputation.

For the next ten years, Maybury concentrated on consolidating his relationships with the social and political elite in Detroit. He dabbled in real estate, held positions as director of a couple of banks and smoothed over the rough edges left by his supporters in his absence. He was a frequent visitor to charitable hospitals and a prominent member of St. Peter's Episcopal Church on Michigan Avenue. He had plenty of spare time, though, to pursue social engagements and entered into a lifelong association with George W. Fowle, a dance teacher and antiques dealer, and Arthur Phelps, a real estate investor. The three spent nearly every evening together, taking in the opera or jaunting off to dinner. This caused tongues to wag in the city and especially in the press, as gossips speculated, with the typical coded language of the time, about the nature of their "bosom companionship." Much of Maybury's later reputation as an effete and ineffectual baby-kisser was the result of newspaper reporter Malcolm Bingay's satirical recollections of Maybury, Fowle and Phelps—and of Bingay's homophobic prejudices.

Meanwhile, the Democratic Party in Detroit was suffering. This mostly had to do with one colossal figure, whose enormous legacy would forever shadow Maybury's and whose antagonism would pester him throughout the rest of his career. Hazen S. Pingree was an unlikely candidate for mayor and an unlikely Republican for that matter. Pingree, a successful shoemaker, took the city by storm the minute he took office as mayor in 1890.

It is hard to imagine two people more different than Hazen Pingree and William Maybury. Pingree was blunt, forceful, argumentative; Maybury was eloquent and reserved, even gentle. Pingree vigorously wielded his new power, shaking up the corrupt system of Detroit politics and refusing to dole out the favors system that the elites expected of him. His reign as mayor brought much-needed improvements to the city of Detroit, which was suffering under severe economic depression and simultaneous growing pains as its manufacturing and shipping industries outgrew the limited infrastructure. He was rightly dubbed one of the greatest mayors in American history, but he didn't achieve this reputation peacefully.

Pingree was a revolutionary; Maybury was a status quo keeper. Pingree was an outlier who shook the system to its foundations and bellowed at his adversaries from the bully pulpit. Maybury worked the parlors, the charity wards and the ballrooms while Pingree stormed through city hall and the board of education, stomping out corruption. Pingree was so beloved by the masses of poor and middle-class Detroiters that his election as governor of Michigan was a given in 1896. The only problem was that Pingree refused to give up his position as Detroit's mayor, insisting that he could serve both roles at once.

This, though, was taking things too far for many of Detroit's legislators. Pingree fought for his right to stay in both roles all the way to the Michigan Supreme Court, but he was eventually forced to choose one. He settled on the governorship and moved to Lansing. Pingree put forth his hand-picked candidate for special election, Captain Albert Stewart, to replace him. But Pingree's heavy-handedness and the fact that Stewart, like Pingree, already held another position in the state government, caused the voters to reject Stewart.

Maybury's nomination to candidacy for mayor was no surprise. As a prominent and well-liked Democrat, Maybury was a soothing balm after years of Pingree's well-meaning bullying. But his election by a narrow margin of only 425 votes was in the eyes of the *Free Press* "a political wonder" that "means a slap at Pingree-ism," especially when paired with the near-complete rout of Republican candidates in Detroit. Stewart had waged a

DETROIT, MICHIGAN, TUESDAY, APRIL 6, 1897.—TEN PAGES.

THE HANDICAP WAS TOO GREAT.

WATCH THE GREAT MAYORALTY HANDICAP

PINGREE WAS TOO HEAVY AND BROKE HIS OWN MACHINE.

Pingree outthinks himself, and Maybury takes the election. *Detroit Free Press Archives*.

nasty campaign full of insinuation and bombast in the weeklong special election, whereas Maybury paid special visits to friends and gave genial addresses to small gatherings. When the increasingly important Polish Republican community publicly declared its support for Maybury, Stewart said sourly, "I didn't care for the Polish support. I have satisfaction in the fact that I carried the more respectable wards."[50] Maybury mildly replied, "I will not indulge in retrospection of some of the unpleasant features that cropped out here and there in the campaign."

With Maybury, the Democrats were back in power, and it was time to show his thanks to the many friends and associates who had helped him get there. First up were his companions George Fowle and Arthur Phelps. Dubbed "The Three Musketeers" by the *Detroit Journal* and caricatured in a series of scathing cartoons, the trio were inseparable in political and personal life, frequenting clubs and social gatherings from New York to Toledo. Maybury appointed Phelps and Fowle as police commissioners, largely honorary

positions that nonetheless wielded considerable influence. It didn't do the trio's reputation any good in the eyes of judgmental Detroiters.

A failed 1900 bid for governor after Pingree's resignation from that post caused Maybury to double down on his commitment to Detroit business efforts. He became an ardent supporter of the Detroit Convention Bureau, founded in 1896 and the oldest in the nation. Maybury's skill at negotiation served him well here. Bureau founder Milton Carmichael declared Maybury "the best talker I have ever heard in my life,"[51] although department store magnate J.L. Hudson was less impressed, complaining, "I don't believe in begging people to come to Detroit. If they don't want to come, let them stay away."[52] Maybury also invested in smaller ventures of his own, including the Maybury and Ellis Company, which produced public mailboxes for the post office; this investment, though, would later prove disastrous to his political reputation.

The year 1901 was a good one to be the mayor of Detroit, especially one whose emphasis on Detroit's hospitality industry drew national attention. In July, Maybury coordinated a three-day jubilee to celebrate the 200th anniversary of Cadillac's landing at Detroit. He hung a massive Welcome sign over city hall and encouraged civic engagement from all citizens. Parades, processions, balls and feasts filled the streets and homes of Detroit, as over 150,000 people celebrated with fireworks and reenactments of key moments from Detroit's history.

Earlier that year, fifty-six prominent citizens led by Maybury banded together and created the Bi-Centennial Box, a copper time capsule filled with letters from captains of industry and politics describing the Detroit of 1900 and predicting what Detroit might look like in one hundred years. Some predictions proved to be a bit off the mark; to date, prisoners are not sent to individual cells via pneumatic tube, nor has the city's population exceeded four million. Yet Maybury's letter, addressed to the future civic leaders of Detroit, shows a man delighted by the ways that technology can bring people closer together:

> *We communicate by telegraph and telephone over distances that at the opening of the nineteenth century were insurmountable. We travel at a rate not dreamed of then. The powers of electricity have been applied marvelously, and compressed air and other agencies are now undergoing promising experiments. We travel by railroad and steam power from Detroit to Chicago in less than eight hours, and to New York City by several routes in less than twenty hours. How much faster are you traveling? How much*

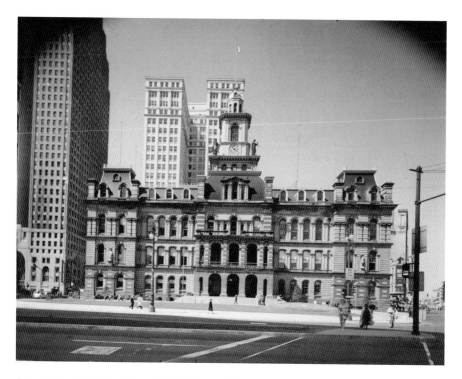

Detroit City Hall, demolished 1961. *Library of Congress.*

farther have you annihilated time and space, and what agencies are you employing to which we are strangers? We talk by long-distance telephone to the remotest cities in our own country, and with a fair degree of practical success. Are you talking to foreign lands and to the islands of the sea by the same method?

Maybury remained humble about his own knowledge and that of his peers. His letter admitted that his prophesies might be wildly off the mark, but it was written in a state of hope and solidarity with the future. Maybury's letter makes no grand pronouncements; it simply marvels at what humans have accomplished and lauds the efforts of others. For his dedication to honoring the city's French past, the French government awarded Maybury the title of Chevalier of the Legion of Honor of the French Republic.

Maybury's genial nature didn't always endear him to some of his rivals, especially the Republican contingent of city council. When a change in state law reduced the boards of many city departments from three-man boards to a single director, Maybury put forth his old friend George Fowle for director

of the board of works. It did not go over well. Ostensibly, the position was supposed to go to a Republican. Therefore, Fowle declared himself a Republican, despite a voting record and personal associations that leaned strongly Democrat. The fight dragged on for months. The Republican contingent of the council refused to approve the appointment and drafted a resolution expressing outrage at Maybury's heavy-handedness. In a rare outburst for the soft-spoken Maybury, he roared that he would continue submitting Fowle's name every single week until the council approved the appointment. In late April 1901, Maybury managed to sway enough councilmen to his side by threatening to allow the state to appoint a director, and Fowle was grudgingly appointed director of public works.

Fowle's first act, just a few hours after taking office, was demonstrative of the sort of hijinks the Three Musketeers engaged in. Around 2:30 in the morning, no doubt lubricated by the extensive application of celebratory cocktails, Fowle rallied about forty public works employees and policemen and, to general merriment and applause, stormed over to Woodward and Griswold and removed some street rail tracks that impeded a pedestrian right-of-way. He was joined about an hour later by Maybury and Phelps, equally tipsy, and the three dashed off in their carriage at the conclusion of this significant achievement. The next day, Fowle penned a lengthy and stern letter to the sewage department, urging management to settle the dispute with striking sewage workers and remove the stench from city streets.

The anti-Fowle Republicans weren't done. They took the fight to the state legislature and rushed through legislation late one night, taking Maybury and Fowle completely by surprise. In the new bill, the power to appoint directors or chairs of any city department went to the city council rather than the mayor. The "Ripper Bill" wrested control from Maybury and planted it back into city council's hands. After five days in office, Fowle was ousted in favor of the (other) Republican candidate. Fowle took the replacement well enough, cordially greeting his replacement and pinning his own badge onto D.W.H. Moreland's jacket. He had a baseball game to get to, Fowle said, and the new guard took over from Fowle and his five-day board with laughter. "They are getting used to these kinds of things over in the public works office nowadays," said the *Free Press*. "If there was a new chief every morning they would appear as unconcerned." But Maybury had ruffled some feathers and lost face in his single skirmish with city council. They would remember this, as would voters, the next time Maybury showed weakness. The affair, wrote the *Free Press*, had "left such a stench in the nostrils of the taxpayers that they never want to hear of [Fowle] again."[53]

THE "PINGREE PUSH."

They Would Be Tickled to Death to Have Mr. Maybury Out of the Way.

"The Old Pingree Push," 1901. *Detroit Free Press Archives.*

In other partnerships, Maybury was far more successful. His childhood friendship with the Ford family fostered an intense loyalty toward the brilliant but stubborn young Henry. Ford may have been a genius, but without Maybury's influence and support, he would likely have been crushed by the stiff competition from other bright young tinkerers. In 1898, Maybury secured a patent in his own name for a carburetor that Ford had built the previous summer. In 1899, he was a primary investor in the fledgling Detroit Automobile Company, which soon went under. By 1900, there were more than sixty different automakers in the city. But on October 10, 1901, Ford took part in a popular and widely publicized race

at the Detroit Driving Club in Grosse Pointe owned by Daniel J. Campau. Watched by more than six thousand spectators, Ford's untested, brakeless, two-cylinder Sweepstakes competed with noted racer Alexander Winton's bigger but more stable car over a twenty-five-mile event. Fortunately for Ford, Winton's car overheated about halfway through the race, and Ford won handily, if not especially speedily.

Employing his typical charm, Maybury used Ford's success at the race to convince investors to give Ford another try. Less than two months later, William Murphy and others agreed to finance the new Henry Ford Company. They brought in Henry Leland in an attempt to hold Ford to the task of building cars instead of racing them. They didn't succeed, and Ford severed ties with Murphy's group due to Ford's inability to live up to his promises of an affordable production car. The group kept Leland on, though, and reorganized as the Cadillac Automobile Company. Finally, though, another successful bout of racing at Grosse Pointe combined with some more wheedling from Maybury, secured Ford investors in his final

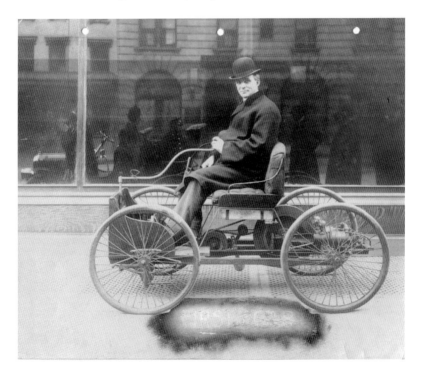

Henry Ford's quadricycle, his first gasoline-powered automobile. *Library of Congress.*

venture, the Ford Motor Company. Organized in 1903, Ford's last venture brought him wealth and prestige. It did not, however, bring any profits to the men Maybury had convinced to invest.

By 1903 the political climate of Detroit was shifting again, and not in favor of Maybury. Voters had not forgotten the Fowle affair. Maybury's passiveness, once viewed as a refreshing contrast to Pingree's forcefulness, was increasingly seen as ineffectiveness. His inability to wrangle the private streetcar monopolies into submissiveness made Maybury look weak, although it would take almost another twenty years and a state law to achieve that goal in the end. In December 1903, news emerged of a far-reaching scheme run by the superintendent of the U.S. Post Office, and Maybury was caught in the crossfire.

When he formed Maybury and Ellis in 1893, the firm won a contract to produce public mailboxes for post offices all over the country. That same year, August Machen was appointed superintendent of the Free Delivery System. Bidding on government contracts was as fraught with corruption then as it can be now. Maybury agreed to give 25 percent of his profits to Eugene Scheble, the owner of the patent on the mailboxes that his company produced. Machen was collecting anywhere from 25 to 50 percent of the profits on each mailbox he commissioned, and he commissioned a lot. In one year, the number of mailboxes ordered by the postal service jumped from 2,700 to 27,000. Everyone made money, Machen most of all. Eventually, the mailboxes piled up in warehouses, and the whole scheme came tumbling down in 1903.

Maybury was never indicted and may very well not have known that Scheble was paying off Machen. That didn't matter to the voters, though. Swept along by Teddy Roosevelt's strong leadership, the Republican Party won resounding victories all over the country in the 1904 election. Maybury lost his reelection bid to fellow University of Michigan grad and city attorney George P. Codd. Gracious as always, Maybury joked after the returns came in that maybe there was a charity somewhere that needed a baby-kisser. He spent his remaining years assisting his cousin William H. Maybury in his political efforts, visiting tuberculosis wards and campaigning for an ultimately unsuccessful canal in Nicaragua.

When he died of heart failure on May 6, 1909, Maybury was remembered for both his kindness and his gentleness, but not for his political success. His obituary conjectured, "Mr. Maybury's kindly disposition and unwillingness to give offense undoubtedly was the reason why he did not achieve a much more brilliant career," but noted that

despite this, Maybury was generally viewed with kindness. Maybury's beloved companion George Fowle immediately began a memorial fund to collect donations for a statue to mirror that of Hazen Pingree in Grand Circus Park. Pingree's monument had been funded just a few years before by an outpouring from the public, small impulsive donations of a nickel or a quarter at a time. Maybury's memorial fund was seeded with a $1,000 investment and largely consisted of donations from businessmen and politicians. The statue was unveiled on November 23, 1912, before a small crowd. George Moody, leader of the association that had raised the funds for the memorial, concluded:

> *Future visitors to the city, when they ride through Grand Circus Park, will pass between two monuments facing each other, one to Hazen S. Pingree, who gained that fame by his strenuous fighting qualities; the other to William Cotter Maybury, who by his gentle manners and quiet dignity brought friends to him and enabled him to accomplish what he undertook.*[54]

What he undertook may not have been much, especially compared to the giant that was Hazen Pingree. The statues stand on Woodward Avenue at Adams, both gazing northward. Pingree looms forward, looking ready to burst from his seat and forcefully stride off into battle. Maybury leans back, a slight smile playing across his face as he gazes serenely into the distance.

PADDY McGRAW

Much Ado about a Brothel Keeper

ookeeper. Philanthropist. Baseball manager. Fiddle player. Vote fixer. And owner of the largest brothel in town, where the young swells from the city slummed it with the factory workers and a meal or a prostitute could be had at any hour of the day. Paddy McGraw was larger than life in a town known for some extreme characters. His heroic charity contrasted with his seedy criminality, and his death capped off a life of contradictions and mystery.

Patrick Joseph, P.J. or "Paddy" McGraw was born in about 1876, and that's all we know about his origins. By the late nineteenth century, he was well established as a "hotel" proprietor, with a massive, two-story saloon and bar on the Detroit-Hamtramck border at Clay Street and St. Aubin. It's possible he was born into the business, like his pal Billy Boushaw. He might have rolled into town on the Grand Trunk Railway line with other enterprising arrivals in Detroit's first industrial boom in the late nineteenth century. However he arrived in Detroit, Paddy McGraw made an impact quickly enough. By the early 1900s, he was an established figure in Republican politics, serving as first an alderman and then a clerk in the first precinct of the seventh ward.

The old ward system of voting was rife with corruption. Just as Billy Boushaw used his clout to control the votes in the transient population of the riverfront, McGraw had his pick of ne'er-do-wells shuttling in and out of his hotel. The area, like much of Detroit, was rapidly changing from rural farmlands with German and Irish families into an industrialized factory town brimming with immigrant vitality. Since McGraw's saloon

was directly next to the railroad junction, he had first crack at many impressionable new arrivals. Riding the wave of optimism brought by the charismatic Teddy Roosevelt, the Republican Party took hold of both houses of Congress and unseated William Cotter Maybury as mayor, with George P. Codd taking office.

McGraw's methods were much the same as Boushaw's: pack his saloon and boardinghouse to the rafters and beyond with alleged residents just in time for Election Day, then send them off to the polls to vote for McGraw's chosen candidate. It was easy to control the results when McGraw could count on the support of his fellow saloonkeepers and fixers such as Boushaw, "Musky" Jacobs, Abe Ackerman, Bert Weiser and "Squangee" Rosenberg.[55] Saloons were more than just places to grab a drink: they served as community centers, banks, jobs board and news agency. The saloon, for many of Detroit's newer immigrants, was the center of life and the place where they acclimated to a strange new town over a common cause: drink.

But the city's rapid expansion also led to more scrutiny of vote-counting methods. The election of spring 1905 revealed some egregious discrepancies in a few precincts, McGraw's included. McGraw was called to fill in for the clerk of another district, the first precinct of the eleventh ward. In "what may modestly be termed a startling discrepancy between the ballots and the returns," more than half of the ballots were recorded in favor of the Republican candidate, rather than the Democrat, as the ballots indicated. At first, McGraw insisted that he hadn't actually been present during the entire day, having stepped out for lunch for several hours. He took a vacation down to Ohio for a couple of days to avoid an inconvenient court summons to explain the discrepancies.

In his absence, the investigation continued. Each ward had three vote counters, and McGraw's fellow counters in the eleventh ward weren't his usual crew. On Election Day, McGraw had served as the "caller." His job was to call out each voter's name and which candidates they had selected to the other two clerks, who recorded the names he called out. McGraw called out the name of his preferred candidates, and those votes were dutifully recorded by the other clerks. But while in his usual ward he had the assistance of his peers to retroactively mark the ballots, the clerks in the eleventh proved unwilling to play ball, and the plot was revealed. It didn't hurt McGraw's popularity, though, as he continued to serve the eleventh until the ward system was abolished in 1908.

One reason for McGraw's popularity was his convivial reputation. Aside from hosting lavish outings for prominent politicians and city officials,

McGraw also was a founding member of the Detroit Goodfellows Old Newsboys' Fund. The group established a charity with the motto "No Kiddie Without a Christmas," and delivered food and gifts to thousands of impoverished families across the city. McGraw was the city's most committed member, spending every Christmas Eve and Christmas Day loading up presents and food to deliver door-to-door. One memorable year, he spent all night distributing nearly two thousand packages. He was prominent in city parades, dressing as Uncle Sam and tossing sweets to the crowd.

Another factor in McGraw's popularity was his heroics. During the time he was fixing votes and pulling rank in political circles, McGraw found the time to pull off a dozen dramatic rescues. McGraw had a summer home on Harsen's Island in the area called the St. Clair Flats. Although the area was popular for day-trippers and vacationers on steamships for its tranquil appearance and abundant hunting and fishing, the Flats, at the junction of the St. Clair River and Lake St. Clair, were also notorious for their treacherous currents. The tall river grasses and water weeds hid entanglements for unwary vacationers, and a carefree afternoon picnic sometimes turned tragic for visitors to the island.

The Old Newsboys in Detroit's 200th anniversary parade. *Library of Congress.*

By 1911, McGraw's reputation for dramatic river rescues was well established. On July 15, when he pulled young Henry Robinson from the river at the Flats, the *Detroit Free Press* reported that he had saved at least one person from drowning "every year for the past six years." Just five weeks later, McGraw was standing at the Belle Isle boat dock at the Detroit River when he spied a young man weakly struggling against the current, about to go under. Without removing his shoes or coat, Paddy dove straight into the river, grabbed the young man and swam him over to the dock, where bystanders pulled him up to safety. This marked his ninth recorded drowning rescue.

Friends and admirers nominated McGraw for a Carnegie Hero Fund Commission award in 1912. The foundation took his application seriously enough to send a private investigator to town for a few days to check out McGraw's heroics, but in the end, the award was granted to someone else. Paddy kept going, undaunted, and as late as 1923, he and a few friends staged the dramatic rescue of a boating party on the Flats, saving five people after a pleasure boat overturned. Among the rescued party was a five-year-old boy and eighteen-year-old Julia Kelley, on whom Paddy performed mouth-to-mouth resuscitation for twenty-five minutes.

The lack of national acclaim from the Carnegie Commission may have had something to do with McGraw's other noted activities, including his ownership of the rowdy but winning semiprofessional baseball team, the McGraw Tigers. Dubbed "a baseball 'hug' approaching the padded cell degree," Paddy McGraw was an avid baseball fan from the earliest days of the sport in Detroit. McGraw's team was not officially linked to the professional team of the same name, but at every opportunity he had, McGraw loaded up his saloon's wagons with his players and local dignitaries and took them on outings to watch the pros play, often wining and dining them lavishly before and after the game. The McGraw Tigers were around for about ten years, and 1910 was by far their banner year. Paddy McGraw built a smart new diamond and stands for his fans and hosted matches against amateur teams from across the city and country, as well as a few matchups with Negro League teams.[56]

McGraw's advocacy for baseball was a smart business move. While he entertained Hamtramck politicians at Tigers games, he was also making deals to set up his field and saloon at St. Aubin and Clay as the go-to weekend spot for entertainment. Although Sunday games had been allowed in Detroit since 1907, drinking was still illegal on Sundays in the city limits. McGraw's bar sat astride the Detroit-Hamtramck border, which made enforcement a nightmare for cops trying to crack down on lawbreakers.

On Sunday game days, a constant stream of visitors debarked the Fourteenth Avenue streetcar line, which was mysteriously and conveniently free of charge on Sundays for passengers heading to McGraw's. The ball park was within Detroit's city limits but had access through a back gate and alley to the saloon. The gate remained open on Sundays with the groundskeeper neglecting to check fans' admittance tickets for entry or re-entry. Very few fans bothered to stick around to watch the game.

Down the center of the largest room in the saloon ran a canvas curtain: on one side, the Detroit-zoned cigar case and tables were closed, but the rest of the bar had room for seventy-five guests and accommodated more than twice that number on Sundays. It was a festive affair, with ice cream vendors set up outside for the thriving business of women and children from the neighborhood. The real party was inside, where raucous and suspiciously young men brawled with toughs from the city, and factory workers drank and gambled away their wages. Outside on the back porch, one visitor found three men passed out in chairs, two fistfights and three women who

McGraw had plenty of women working in his saloon—upstairs at least. *Library of Congress.*

led visitors by the hand to the upstairs room of the hotel. Out in the yard, McGraw's menagerie of bears, dogs, big cats and monkeys watched the spectacle with puzzlement.[57]

The twenty-five-foot bar hosted another sort of guest: "men from the city, well groomed, well dressed, wearing flashy jewelry, resembling in every way the smooth chap who lives by his wits rather than by toil." Paddy McGraw's was well known as a haven for criminals from all walks of life. Thanks to his nephew, a justice of the peace, as well as his friendships with city council members and police officers from Hamtramck, McGraw functioned outside of the legal circles, and the cops were more likely to be patrons of the bar than to try and interfere with his business. During the "slambang days" of McGraw's, one bouncer recalled Paddy's famous Saturday night dances, when resident prostitutes were courted by young men from all walks of life. "If there wasn't a fight about every ten minutes," bouncer Fred "Kid" Wellman noted, "the dance would have been considered a failure." On such nights, "the toughest of the underworld was present," and things got pretty rough. Wellman was kept on staff to break up the worst of the rowdiness. One night, a young tough named Clancy grabbed hold of a woman who was dancing with another patron. She objected, and the men started swinging. By the time Wellman intervened, Clancy had knocked his opponent clear across the floor but was still itching for some violence. When Wellman tried to grab hold of Clancy, Clancy threw a roundhouse punch but missed the nimble bouncer and instead broke his hand on the iron pillar supporting the ceiling and bent the bar. Despite this setback, it still took Wellman and three other men to subdue the enraged Clancy.

Offenders at McGraw's weren't sent to jail. Instead, Paddy and his boys took care of things themselves. Anyone disturbing the peace was first given a stern talking to and maybe a bit of a roughing up, and repeat offenders were banned. McGraw's may have been home to many criminals, but the genial Irishman ruled his rowdy roost with an iron will. He loved to entertain and wasn't too picky about who stopped in of an evening, and McGraw's was generally packed with a wide variety of customers, from businessmen sojourning for an evening from Chicago to career pickpockets and racketeers. Located as close as it was to the main westward railroad lines, McGraw's became well known as a stopping point for a good conversation with a pretty lady and perhaps more. One historian claimed that McGraw's was the largest brothel in the Midwest at the time.[58]

McGraw's was a haven for criminals. In 1915, Albert Hall entered his home on Joseph Campau Street to find two burglars ransacking the

place. He gave chase and managed to track one of the men to McGraw's, where the thief was calmly drinking a beer and chatting with Paddy. Hall hightailed it to the police station and brought reinforcements to arrest the man; when they arrived, Paddy proved belligerent and was hauled off to court. Charges against McGraw were dropped, though, after witnesses refused to come forward on Hall's behalf. The unlucky Tommy Teahan, "Jail Champ" of Greater Detroit, was another regular patron. Poor Tommy was an unredeemable sot, racking up over 100 arrests and 94 convictions on crimes from public intoxication to indecent exposure. When he was arrested for the 111th time, he was found passed out in an alley with an expensive Airedale terrier tied to his leg. Teahan told the judge that he'd brought the dog along with him in the hopes that the police would take pity on him and the terrier and refrain from arresting him on this occasion. Although at first Teahan claimed that he'd purchased the dog, he later admitted that it was a gift from Paddy McGraw. The ploy worked this time, and the judge released Teahan and the terrier to McGraw's care.

On another occasion, during the heated 1908 elections, McGraw's bartender found a suspicious man lurking around the premises asking questions. The tall man queried the bartender, the barmaid, the cook and even the chambermaid about who was in residence on voting day. McGraw soon apprehended the man and "with much shaking and quivering, the 'detective' gave up a number of notes he had taken." But Paddy wasn't satisfied with kicking the man out of the joint. He grabbed the terrified spy by the scruff of the neck and marched him over to the telephone, where he forced the man to call his boss, a lawyer working for one of McGraw's political rivals. McGraw then told the lawyer that he'd best stop sending spies over to his place. In fact, he said, if the man or his employers wanted information about the goings-on at McGraw's on election day or any other day, they should feel free to call Paddy himself and he'd give the information for free.

One memorable evening during Prohibition, McGraw was hosting a lively gathering of the usual suspects. Among the crowd were three Wayne County sheriff's officers. They were there, they insisted, to scope out the place in order to secure evidence for a future raid. When they left McGraw's they were set upon by a pair of Hamtramck police officers. A rather undignified brawl ensued, the result of which was the Hamtramck officers slapping the Wayne County officers in handcuffs and hauling them off to jail. The Wayne County sheriff was outraged and demanded retribution from the Hamtramck cops, claiming that "all the trouble came though the hostile

The genial saloonkeeper. *Library of Congress.*

attitude of Hamtramck officers toward our efforts to find violations of the prohibition law in their city." When asked why his men had been spotted inside McGraw's with beer in hand, he declined to comment.[59]

Of an evening, Paddy McGraw was known to bring out his fiddle and serenade his guests with plaintive songs from the old country and jigs to get the dancers' toes tapping. For years, he made the rounds with his wife, Sophia, whom he'd married in 1894. Sophia was a working girl at the saloon before he married her, and she continued to help out with the housekeeping and the running of the bar. One duty she hated most, though, was caring for his ever-growing menagerie of stray dogs and cats and more exotic animals. In 1922, she sued Paddy for divorce, citing overwork and neglect from her husband. She was tired, she said, of watching him cavort with other women while she toiled away. The last straw for poor Sophia was when one of Paddy's pet monkeys viciously bit her on the shoulder, leaving a large scar.[60]

The court granted Sophia her divorce. For years, Paddy McGraw had been most often seen in the company of pretty Minnie Yago, another one of his saloon girls who also worked as a prostitute from time to time. The pair

Paddy McGraw's violin and Newsboys' bag at the Hamtramck Historical Museum. *Photo by the author.*

were together for nearly twenty-five years, taking up together not long after his marriage to Sophia. Minnie squirreled away a sizeable sum of money, and Paddy happily moved into her mansion on Fischer Street and declared himself her common-law husband, his marriage to Sophia notwithstanding. Minnie and Paddy swanned about town, dividing their days between the saloon and the Fischer Street house and summering on Harsen's Island, where Paddy continued to pull hapless swimmers from the waters.

Minnie and Paddy's life together was tempestuous, and the Spanish beauty and the passionate Irishman fought often, sometimes physically. When she died at Christmas in 1923, Paddy was distraught. Minnie's sister was even more distraught, though, since Paddy continued to occupy the Fischer house and help himself to Minnie's savings. Minnie's death was officially ruled a heart attack, but Minnie's sister, Emma Menig, was convinced that Paddy had either beaten her to death or poisoned her. She demanded that McGraw move out of the house and hand over the keys, and she sued the courts for Minnie's body to be exhumed and examined for injuries.

Emma Menig's suit alleged that Minnie Yago had confided in a gentleman friend just days before her death. Minnie said that Paddy beat her, and she was afraid for her life but still loved Paddy because he had promised to marry her someday. The coroner would find two broken ribs, Emma claimed, and she would only reveal who had assaulted Minnie if the examination proved Minnie died unnaturally. Meanwhile, Emma still wanted Paddy out of Minnie's house. On the day of the exhumation, Paddy turned over the house keys to a judge.

The coroner's report stated that Minnie had indeed died of natural causes and that there were no mysterious or unusual marks on her body. Paddy promptly turned around and sued the Menigs for defamation, asking $50,000 for "great mental anguish." It took nearly two years to sort out the mess. Emma Menig claimed that McGraw had squandered away her sister's money, controlling access to her accounts and doling out a tiny pittance to Minnie only after she begged him. McGraw countered by stating that he had fronted the down payment on the Fischer house and that he paid the mortgage and bills. The sparring in-laws finally reached a settlement, whereby McGraw withdrew his lawsuit and received a pittance, just $750 of Minnie's $12,500 estate.

McGraw didn't need the money. He was more concerned about the slight to his reputation and the insinuation that he had beaten Minnie Yago. He was a gentleman's gentleman, McGraw insisted, and although he might be rough with his customers when they got out of line, this was a necessity

when you ran with such an unruly crowd. McGraw had his fair share of scrapes with the law but managed to squeeze under the radar as the old era of the saloon was slowly eroded by new drinking habits during Prohibition. Perhaps surprisingly, the end of Prohibition also spelled an end to Paddy McGraw's sway over Detroit's drinkers. The rowdy saloon was no place for genteel folks, and cocktail culture never really took off at Paddy's. The bar shut down in 1933 and quietly moldered for years until it was torn down to make way for the massive General Motors Poletown Plant.

Paddy McGraw retired to his vacation home on Harsen's Island. He never did lead a quiet life, though, and continued to drink hard and party harder to the end. On June 28, 1936, McGraw was up late drinking with some friends at his cottage, including William Timm and McGraw's "housekeeper." Jack Gillis, who lived next door to McGraw, wandered over to the party, so drunk he could barely stand. Witnesses' recollections were hazy due to the vast quantities of alcohol consumed by all present, but a special investigator was able to ascertain the following: McGraw decided to do some late-night repairs and stood on a chair to fix a light bulb overhead. Gillis was belligerent. So was McGraw. A fight ensued, and Gillis pushed McGraw from his chair, then grabbed the chair and swung it at McGraw, connecting with his abdomen. McGraw went down hard and never got back up again. By the time everyone had sobered up, McGraw had been carted off to the morgue and the investigation had begun.

Unlike Minnie's death, Paddy McGraw's body didn't have to be exhumed before examination. Much like hers, though, McGraw's death was ruled natural, as he was found to have extensive heart disease caused by years of hard living. Gillis probably hadn't done McGraw any favors by walloping him with that chair, but he was never charged for the attack, since the now sober witnesses recalled that McGraw had hit Gillis first. Paddy McGraw exited the Detroit scene as brashly as he had entered it, drinking, fighting and causing headlines. He wouldn't have had it any other way.

CHARLES BOWLES

A Shameful Chapter in Detroit's History

There's only one mayor in the long history of Detroit's wickedness to be removed from office by vote of the people. There's no glossing over the rotten, nasty life of Charles Bowles. Even allowing for the lawlessness of Prohibition, the "short, gaudy" reign of Bowles—and the fact that he was ever elected in the first place—stands as mute warning to future Detroiters that hate only breeds more hate. Bowles held office for only seven months, but the bigotry and corruption he left in his wake soured voters for many years after.

Bowles's origins were innocuous enough. Born in Yales, Michigan, in 1884, he attended what is now Ferris State University and, like many of the other scoundrels in these pages, attended law school at the University of Michigan (no slight intended to either lawyers or Wolverines). He passed the bar in 1909 and settled in Detroit as a small-time litigator. He married Ruth Davis a few years later in 1915. Many of Bowles's early cases covered contested wills. He established an early reputation as a dogged litigator, willing to go to any lengths to win a case. One early case involved a contested will: a quarreling doctor and his wife separated but never divorced, and he paid her a set amount every month until his death. Upon his death, though, the doctor's will stated that only $1,500 of his estate would go to his widow; the rest was to be given to the executors of his estate. When the widow sued the executors of the estate, claiming they exerted undue influence on her husband when he was in a frail mental state, Bowles countered by insinuating that she had behaved immorally, cavorting around town with several suitors during her

husband's illness (including her parish priest). Eventually, the widow gave up her suit, and the case was settled in favor of the estate's executors: Joseph Lukaszewski, John Dysarz Jr. and Charles Bowles.

Ruthless and determined, Bowles achieved his success as a lawyer by way of insinuation and rumor. He soon had opportunity to ply these skills on a grander scale. Detroit mayors in the first half of the twentieth century had a habit of not filling out their terms, resigning for illness or, in the case of Hazen Pingree and others, to make a grab at another political office in Michigan. In 1924, Mayor Frank Doremus resigned due to illness, and

Charles Bowles, 1930. *Burton Historical Collection.*

a special election was held in the fall to replace him. Against acting mayor Joseph A. Martin and new candidate John W. Smith, Bowles, a complete unknown, tossed his hat into the ring.

More appropriately, perhaps, he tossed his white hood into the ring. Bowles had no political experience, but he did have the fervent backing of one of the country's emerging political powers: the Ku Klux Klan. By 1924, the Klan bragged of over 200,000 supporters in Detroit. The Great Migration, spurred by industrial growth in the Midwest, brought more than 6 million African Americans from the South to the Midwest during this period, and tensions flared in Detroit as the influx of settlers shook up established all-white neighborhoods. Pinning their hopes for political power on Bowles and on Detroit in general, the Klan rolled out a vicious anti-black and anti-Catholic platform.

Although Bowles denied that he was a member of the Ku Klux Klan, he was more than happy to take its money and the support at rallies. In fact, without the Klan, Bowles likely wouldn't have run for office. Declaring that "a satisfied citizenship is the best political machine," Bowles campaigned to "clean the city from stem to stern" by being tough on crime. He had neglected, however, to file the appropriate paperwork to enter the election and, as a result, had to compete as a write-in. At the time, Bowles was called a "sticker candidate" for the stickers printed with his name that were handed

to voters on Election Day. Bowles's campaign also distributed tiny red schoolhouses as a protest against private schools, especially Catholic ones.

Bowles's primary opponent, John W. Smith, was appalled at Bowles's vocal Klan support. The Klan's involvement in politics, he warned, was "a menace to the future domestic government and national standing of Detroit." Two weeks before Election Day, a respected anti-Klan speaker was scheduled to address a crowd in Detroit. As the talk began, though, over six thousand pro-Bowles demonstrators blocked city streets and mobbed police escorts. Even riot gear, night sticks and tear gas couldn't contain the mob, which held up traffic and streamed across Woodward Avenue for hours. Inside the venue, a group of seven hundred listeners stood up and walked out en masse in protest against the anti-Klan speaker. Once outside, they merged with the larger crowd, slapping Bowles stickers on passing cars and chanting their candidate's name. The crowd moved aside only for a parade of cars—carrying Klan members with loudspeakers urging citizens to vote for Bowles—bedecked with Bowles banners.[61]

The Ku Klux Klan, which backed Bowles for Mayor, raising crosses in 1925. *Library of Congress.*

Despite the disturbance and the blatant public support of the Ku Klux Klan, Bowles still insisted that he was not a member of the Klan—although he welcomed any voter who believed in his ticket. Throughout the campaign, he pretended to play the middle, both with his bigoted supporters and with his views on the campaign's major issues. Bowles was never an issues candidate; he was the strident advocate of personal politics and private fears. In an address to a women's organization, he declared, "The city has become the mecca of all kinds of crooks and is getting an unsavory reputation that is spreading across the country. As your mayor I will do all in my power to end this evil influence and will clean the city from stem to stern."[62] In the coded language of the time, of course, that "unsavory reputation" and the "crooks" Bowles referred to were the newcomers to the city, non-WASP immigrants and factory workers. And within a few years, that unsavory reputation that he'd promised to repair would be heightened by his own criminal actions.

His abuses of power, though, would have to wait. In the special election of 1924, Smith defeated Bowles by ten thousand votes. It was the largest voter turnout in Detroit history to that date, especially impressive for a special election held for a temporary mayor—90 percent of eligible voters turned out at the polls. Bowles immediately demanded a recount, accusing Smith, the city clerk and anyone else he could find of fraud. Smith offered to pay half of the recount fees on Bowles's behalf, so confident was he that the numbers would run in his favor. The recount showed that over seventeen thousand ballots were disqualified; Detroit has always had difficulties keeping its voting procedures on the level.

It was a close call for Detroit. An unknown candidate, with no formal positions on any city policies and with only the Ku Klux Klan to vouch for him, came dangerously close to the highest position in city government. The *Free Press* acknowledged the stain on the city's reputation presented by Bowles's popularity:

> *He entered the mayoral race in a manner repugnant to the whole spirit and intent of the city charter. And it is decidedly disquieting to find that such a candidate can roll up a total of more than one hundred thousand votes in this city, purely as the beneficiary of a wave of religious prejudice. It is especially unpleasant to find that the women, from whom the country expected a great deal when they received suffrage, were particularly numerous and ardent in their support of Mr. Bowles. The total disregard of the real purpose to be served in electing a mayor which almost a third of the electors of Detroit showed in casting their ballots, is particularly ominous.*[63]

It was ominous indeed, and much of Bowles's voting base was made up of churchgoing women and the working men of the streetcar conductors' union.

The regular election for Detroit mayor was held the following year, and the same groups avowed their passionate support of Bowles. This time they were more organized and better funded. Bowles's rallies now included white-hooded marchers and burning crosses all over the city. He continued his coy dance with the Klan but admitted that he was happy for the support of anyone willing to speak against the "criminal element." On the eve of Election Day, Ku Klux Klan women marched door-to-door through the city, haranguing voters and chanting slogans. At dark, they were replaced by a cadre of men in hoods and white cloaks, many of whom burned crosses on the lawns of frightened residents. The wife of a prominent downtown pastor held a large rally for women voters at the Fort Street Congregational Church and declared, "Every woman who does not vote November 3rd, and who does not vote for Charles Bowles, should be tarred and feathered!"[64] Bowles's response to these efforts and the heated rhetoric behind them expressed that he was "proud of the worthy people who have flocked to my standard of clean government."[65]

Not everyone was stood behind Bowles's nasty campaign, though. After Bowles backed out of a promised radio debate, the *Detroit Saturday Night* paper published a scathing critique, calling him "The Visible Candidate of the Invisible Empire," noting, "In the face of a movement that strikes at the very vitals of American liberty, Mr. Bowles proclaims his neutrality—and gets aboard." The paper warned that "this revival of medieval bigotry" would have long-lasting repercussions, regardless of the outcome of the election.[66] Indeed, it wasn't just the mayoral vote at stake: the Klan had endorsed five candidates for city council, and early in the election, those five were leading in polls.

Fortunately for Detroiters, Bowles lost the election by about thirty thousand votes. Phillip Callahan, former Cyclops of the Ku Klux Klan, was the only one of the five elected to city council. Bowles's home district on the northwest side of town, which had initially been strongly in his favor, delivered the killing blow and voted for Smith in high numbers. Still, the Klan had effectively insinuated itself into the political system. "If the Klan became a nonentity on the surface," said the *Free Press*, "its disassembled units did not die off nor their hallucinations perish."[67]

Setting his sights on a more achievable goal, Bowles ran for and won a position as a judge on the recorder's court. From 1926 to 1929, Bowles ruled on many criminal cases in Detroit. His "tough on crime" attitude

Fort Street Congregational Church at Fort and Wayne. *Burton Historical Collection.*

extended here, too, and he earned a reputation for harsh sentencing for Prohibition violators. Bowles repeatedly attacked the Detroit Police for laxity of enforcement and set extremely high bail for even minor violations. In one case over which Bowles presided, a repeat offender prostitute was arrested for loitering in a house of ill repute. A recently passed rule allowed judges to comment on evidence in misdemeanor cases, and Bowles took advantage of that rule. Telling the jury that it was their moral duty to find the woman guilty and hand over the harshest sentence possible, he insisted that no excuses should be tolerated for even minor misdemeanors. The jury found the defendant not guilty.

Bowles was tough on crime all right—except for the crimes committed by his allies. One of the defense lawyers he frequently worked with, Carl Weideman, always received lenient sentences for his clients, underworld figures in charge of vast gambling rings and saloons. In 1929 alone, Bowles acquitted 125 gamblers, 9 gambling house owners and 59 Prohibition violators, all clients of Weideman. He also introduced a proposal to reduce

the operation of a slot machine from a felony to a misdemeanor, claiming it would speed up the trial process and reduce backlogs of cases. The police commissioner, William Rutledge, disagreed, and the proposal didn't pass.

By 1929, Bowles was ready to make another go at the mayor's office. With Weideman as his campaign manager, he launched a vicious "whisper campaign" against his old foe, Joseph Smith. He started by rehashing old grievances, insisting that the city clerk had committed fraud in the 1925 election and robbed Bowles of a majority vote. Bowles's insinuations against Smith, largely spread by women campaigners, alleged the following: Joseph Smith was not the candidate's real name, Smith was divorced and Smith's primary lead of eighteen thousand votes came from rigged ballots perpetrated by an east-side mob. Absolutely none of this was true, of course, but the rumor mongers loved the salacious gossip and spread the insinuations further.

Bowles got hold of a copy of an African American Detroit publication endorsing Smith for mayor. His office printed 200,000 copies of the paper and distributed them all over town, especially focusing on areas of the city "where it was believed race feeling would make an impressive argument," according to the *Free Press*.[68] He distributed a circular claiming the endorsement of prominent and respected businessman William Walker, who then had to hold a press conference refuting these suggestions and endorsing Smith. Advertisements by the Bowles campaign claimed the endorsement of acting mayor John C. Lodge, who also had to remind reporters that he was voting for Smith.

Bowles's campaign took out full-page ads attacking Smith in the week before the election. He declared, "Charles Bowles asks only the support of these better citizens. He has openly pledged himself to rigid enforcement of the law, and has stated that the kidnaper, racketeer and hold-up man must go." Smith responded by asking, "Why does every self-seeker, every gunman, every racketeer, every gambler, support Bowles? Why does every enemy of honest, decent government back Bowles?"[69]

Bowles won the election by a mere 7,800 votes, prompting circuit court judge Alfred Murray to call for a recount and refuse to certify the election results. He found 192 votes from deceased voters in one precinct, and asserted that at least 10 percent of the votes overall were fraudulent. Eventually, the election results were certified, and Bowles was inaugurated on July 14, 1930.

Bowles's first act in office was to call for an extension of mayoral terms from two to four years, which was shot down handily. His second act was the firing of respected police commissioner William Rutledge and replacing

him with newcomer Harold Emmons. Bowles inherited a city that was desperately struggling through the beginning of the Great Depression, when unemployment and crime were rampant and the city was wide open to gangsters and rumrunners. Bowles's right-hand man, John Gillespie, was dubbed "the de facto mayor of Detroit." Gillespie had faded from public view for a while after he was removed from office under Mayor Oscar Marx in the same scandal that had taken Billy Boushaw out as an influencer in the city. Bowles appointed him director of public works.

Now, though, Gillespie had free rein to cozy up to the criminal elements. Within days of Bowles taking office, illegal gambling houses opened their doors—one of them, the Brass Rail, was visible from Bowles's office at city hall. Gillespie and Bowles formed a centralized vice squad for the city against the strenuous objections of every police department head; Gillespie's 1916 vice squad had been disbanded due to rampant corruption. Rather than making it easier to clean up crime, the vice squad only centralized the corruption, especially once Bowles ordered his new police commissioner, Emmons, to force over thirty officers into early retirement.

It didn't take long for word to spread that Detroit was open for business. By April, the state police department's Detroit head, Richard Elliott, was complaining that criminals from downriver had packed up and moved shop to Detroit and that Chicago gangs were openly running the streets. The vice squad's laxity was remarkable: the eighty-five-man squad managed only twenty-one arrests in one week, almost entirely prostitutes. Somehow, not a single gambling operation was shut down. The day that the grand Aniwa Club on Jefferson and Van Dyke reopened, openly displaying roulette wheels and poker games, Commissioner Emmons left town on a two-week trip to Los Angeles.

When Bowles announced a new commission to deal with the extensive litter problem in the city, the papers had a field day. It was obvious by now that Bowles was in the pockets of the gamblers and the gangsters. The *Free Press* joked:

> *Gunmen who litter up the boulevards of this fair port, take warning. Under the rules of the health department, all discharged cartridges must be picked up by the owner and deposited in one of the municipally-provided rubbish cans. Shedding of blood on public property will be considered a particularly serious offense. Think twice before you leave your victim's body out in the open.*[70]

Bowles instituted a "hush policy," refusing to release arrest and crime statistics to the public. In fact, his office refused to speak with the press at all, and he spent most of his time closeted in his office with Gillespie and receiving daily visits from casino owners, including the owner of the Brass Rail. Just days after Emmons returned from his lengthy trip out west, Bowles and Gillespie departed for Louisville to watch the Kentucky Derby.

Emmons saw his opportunity and decisively acted. He gathered the majority of his police force and paired them with crime reporters who could point out the worst of the vice offenses in the city. Police officers were handed a slip of paper with an address, all at the same time, and a reporter accompanied each group of cops as they busted multiple high-profile gambling operations. In a single afternoon, police arrested more than 250 people caught in the act at downtown casinos. It was a calm, calculated and well-coordinated effort. And it took Bowles and Gillespie completely by surprise.

Bowles's response from Kentucky was yet more silence. Emmons continued the crackdowns in Bowles's absence, declaring he had no intention of stopping any time soon. He intimated that this was just the first step in a vigorous campaign to actually clean up crime and that nothing short of arrest would stop him.

Immediately on his return to Detroit, Bowles fired Emmons, replacing him with Thomas Wilcox from the Detroit division of the Department of Justice.[71] A special messenger arrived at Emmons's office with the mayor's letter, and photographers were there to capture the moment as Emmons wryly smiled and accepted his dismissal. Raids scheduled for that night were canceled by order of Gillespie and Bowles. Bowles himself drafted a resignation statement by hand for Emmons to publish, in which Emmons was to admit that he targeted the operations out of political and personal spite. Instead, Emmons went to the press, disclosing secret conversations and handing over evidence that Gillespie was in league with some of the worst criminals in town. He proved that Bowles had been bought by the rumrunners and the vice peddlers.

Emmons's firing was the last straw for the people of Detroit. Within two days of Emmons's statements, a recall campaign was in full swing and had already raised over $30,000—much of it from Bowles's former supporters in legitimate businesses. Their petition for Bowles's recall cited twelve major reasons for ousting him, including Gillespie's private company receiving a $10 million city contract on the same day as the gambling raids. Gillespie fought the recall by using city employees, including police officers, to

intimidate voters and prevent them from signing the petition for a recall election. Bowles took the case to the Michigan Supreme Court twice and lost both times.

Despite these efforts, Detroiters had had enough. July 1930 was an especially brutal month in Detroit: a record heat wave killed four people in one day, and the first two weeks saw eleven murders, nine of which were tied to organized crime. Tensions were high. City vehicles paraded the streets with Bowles banners, and ballot workers were instructed to take all of the ballots to one central location for counting, overseen by Gillespie. On the day of the election recall, popular radio host Jerry Buckley broke his silence and demanded that voters turn out to remove Bowles.[72]

It worked. Echoing the 1925 election that had denied Bowles the mayor's office, a record number of voters turned out despite the searing heat. By a margin of over thirty thousand voters, Bowles was removed from office. That same night, July 22, 1930, radio host Buckley was shot and killed by three gunmen in front of a dozen witnesses in the lobby of the LaSalle Hotel. Wilcox's botched investigation only did further damage to Bowles's reputation. In the new mayoral election that fall, Bowles ran against a bevy of candidates, including, briefly, former police commissioner Emmons.

The surprising winner was a thirty-seven-year-old recorder's court judge from the Thumb area of Michigan. Frank Murphy was a relatively unknown judge who had presided over the famous Ossian Sweet trial in 1925, at the very same time as Bowles's second unsuccessful election run. Sweet, an African American doctor, had purchased a home in an all-white neighborhood. When a mob gathered on his front lawn and starting throwing stones at the house where Sweet and his family were, he and his brother fired into the advancing crowd, killing one man. The case made national headlines. Clarence Darrow, of the Scopes Monkey Trial fame, was defense council for two trials, first of Sweet and nine other defendants, then of Sweet's brother Henry. The first ended in a mistrial and the second in a not guilty verdict for Sweet. Murphy's cool-headed and compassionate oversight of the case would later convince Detroiters that he was the right choice to replace the divisive Bowles.

Murphy later went on to an illustrious career in state and federal government, ending as a U.S. Supreme Court justice, where his comrades valued his progressive social justice rulings and his kind temperament. His style of judgement was jokingly referred to as "tempering justice with Murphy." In his acceptance speech to the beleaguered citizens of Detroit, Murphy offered a soothing balm:

The people of Detroit have recaptured their government. Without a machine, without a campaign "slush" fund, with only the unselfish labors of volunteer workers, but with unfaltering faith in the people, this fight has been fought and won.

Detroit can again lift her head proudly among the cities of the nation because her citizens have proved their intelligence, civic patriotism and determination to have a clean city under a clean and efficient city government.

This is the people's victory—not mine.[73]

Bowles bitterly contested the election, of course, shouting that "the whole thing is a gigantic conspiracy and a fraud." No one listened, though. Murphy was the fresh start the city desperately needed to get through the challenging years of depression.

Bowles spent the rest of his life chasing the fame and power of his glory days, to no avail. He ran for Congress in 1932 and 1934 and lost. A bar owner placed an ad in his name for the 1943 mayoral race as a prank. Bowles ran for his old office, recorder's court justice, in 1945 and again in 1950 and was soundly defeated. He never again held public office. After his wife, Ruth, died in 1937, Bowles remarried in 1940, and his second wife divorced him three years later, denouncing him as a bitter, abusive man.

Charles Bowles died on June 29, 1957. In his will, he left the entirety of his estate to an educational trust for his five grandchildren. His ex-wife received two broken lamps.

NOTES

Chapter 1

1. *Collections and Research Made by the Michigan Pioneer and Historical Society* 14 (1930): 203.
2. Monetary currency at the time was an exceeding complex system. New France wavered between the use of livres and pounds, and the value in North America of these currencies was about 25 percent of that in Europe.
3. Durand, "Why I'll Drive."
4. Cadillac to Pontchartrain, October 5, 1701. *Excerpts from the Michigan Historic and Pioneer Collections* 29 (1901): 301.
5. Vaudreuil to Pontchartrain, *Collections and Research* 14, 405.
6. Ibid, 408.
7. Kirby, *Wicked Mobile.*

Chapter 2

8. Carlise, *Chronogrophy of Notable Events*, 99–100.
9. Palmer, "Detroit in 1827," 278.
10. Bill McGraw, *Detroit Free Press*, February 22, 2001.
11. For a detailed history of Detroit and slavery, see Miles, *Dawn of Detroit.*
12. Paré, *Catholic Church in Detroit*, 299.

13. Ibid, 323.

14. Letter to George McDougall, November 30, 1811. In *Michigan Historical Collections* 8: 602.

Chapter 3

15. Quoted in Woodford, *Mr. Jefferson's Disciple*, 19.

16. Farmer, *History of Detroit and Michigan*, 181.

17. Woodford, *Mr. Jefferson's Disciple*, 40.

18. A.B. Woodward to the People of Detroit, December 1806. Quoted in Farmer, *History of Detroit and Michigan*, 39.

19. Petition from Inhabitants of the Territory, 1807, Pittsburgh Commonwealth, December 9, 1807, Quoted in Woodford, *Mr. Jefferson's Disciple*, 46.

20. A full and masterful scholarly account of slavery in Michigan can be found in Miles, *Dawn of Detroit*.

21. The Denison Decision, quoted in Woodford, *Mr. Jefferson's Disciple*, 86.

22. Woodford, *Mr. Jefferson's Disciple*, 96.

23. Ibid., 109.

Chapter 4

24. New England Historical Society, "William Hull Tries to Save Nathan Hale," http://www.newenglandhistoricalsociety.com/william-hale-tries-to-save-nathan-hale.

25. Letter to James Madison, Albany, April 30, 1806. In *Michigan Pioneer and Historical Collections* 31 (1902): 559.

26. *Michigan Historical Collections* 8 (1886): 590.

27. Yanik, *Fall and Recapture*, 44.

28. Ross and Catlin, *Landmarks of Detroit*, 319.

Chapter 5

29. "Edward D. Brown," https://www.racingmuseum.org/hall-of-fame/edward-d-brown.

30. *Detroit Free Press*, August 28, 1880, 1.

31. Ibid., July 16, 1886, 5. By 1891, the battle over private and public streetcar fares led to days of streetcar riots, where striking drivers clashed with scabs and angry citizens derailed Hendrie's cars from the tracks.
32. Ibid., February 5, 1889, 3.
33. Hervey, "Leaves of Old-Time Trotting Politics." I am indebted to the Discuss Detroit internet forum for its lively discussion of harness racing in old Detroit, and this chapter is informed by several of the posts there.
34. *Detroit Free Press*, July 17, 1894, 1.
35. For an excellent examination of Fairview's existence from 1903 to 1907, see Sinacori's "Village of Fairview."
36. Hervey, "Among My Correspondents," March 2, 1938.
37. Ibid.

Chapter 6

38. *Detroit Free Press*, December 18, 1937, 1.
39. Lodge, *I Remember Detroit*, 98.
40. *Detroit Free Press*, September 28, 1908, 1.
41. Ibid., August 7, 1903, 59.
42. Ibid., August 18, 1912, 2.
43. Ibid., November 18, 1914, 6.
44. Ibid., November 8, 1916, 66.
45. Ibid., March 6, 1917, 7.
46. Ibid., February 10, 1932, 5.
47. Ibid., December 20, 1937, 6.

Chapter 7

48. April 23, 1884 Report on the Findings of the Judiciary Committee. Quoted in Anthony and Harper, *History of Women's Suffrage*.
49. *Detroit Free Press*, September 7, 1886, 4.
50. Ibid, April 5, 1897, 1.
51. Ross and Catlin, *Landmarks of Detroit*, 716.
52. *Detroit Free Press*, January 29, 1900, 2.
53. Ibid., May 5, 1901, 3.
54. Ibid., November 24, 1912, 1.

Chapter 8

55. *Detroit Free Press*, December 31, 1949, 10.
56. Ibid., August 4, 1910, 2.
57. Ibid., July 22, 1912, 2.
58. Kowalski, *Wicked Hamtramck*.
59. *Detroit Free Press*, March 12, 1923, 1–2.
60. February 10, 1922, 13.

Chapter 9

61. Ibid., October 22, 1924, 14.
62. Ibid., November 1, 1924, 13.
63. Ibid., November 6, 1924, 6.
64. Ibid., October 23, 1925, 1.
65. Ibid., November 3, 1925, 1.
66. *Detroit Saturday Night*, October 31, 1925.
67. *Detroit Free Press*, November 17, 1929, 87.
68. Ibid., October 29, 1929, 1.
69. Ibid., October 25, 1929, 1–2.
70. Ibid., April 20, 1930, 1.
71. Wilcox would later be jailed on multiple counts of racketeering and corruption.
72. Gillespie later had a complete breakdown, stole two guns from his brother and went missing for several months. He turned up at the home of a prominent politician, having stalked him and made multiple death threats. Gillespie was remanded to the care of a doctor and died bankrupt a few months later.
73. *Detroit Free Press*, September 10, 1930, 1.

BIBLIOGRAPHY

Anthony, Susan B., and Ida H. Harper. *History of Women's Suffrage.* Part 2: *The Trailblazing Documentation on Women's Enfranchisement in USA, Great Britain & Other Parts of the World (With Letters, Articles, Conference Reports, Speeches, Court Transcripts & Decisions).* Google Books, 2017.

Askin, John. Ed. by Milo M. Quaife. *The John Askin Papers.* Detroit, MI: Detroit Library Commission, 1931.

Bates, Beth Tompkins. *The Making of Black Detroit in the Age of Henry Ford.* Raleigh: University of North Carolina Press, 2012.

Bingay, Malcolm. *Detroit Is My Own Home Town.* New York: Robbs-Merrill Company, 1946.

Boyle, Kevin. *Arc of Justice: A Saga of Race, Civil Rights, and Murder in the Jazz Age.* New York: Henry Holt and Company, 2004.

Bragg, Amy Elliott. *Hidden History of Detroit.* Charleston, SC: The History Press, 2011.

Brock, Isaac, to William Hull. August 15, 1812. *Excerpts from the Michigan Historic and Pioneer Collections* 40 (1929): 451.

Burton, Clarence. *Barnabus Campau and His Descendants.* Detroit, MI, 1916.

———. *The City of Detroit and Michigan, 1701–1922.* Detroit, MI: S.J. Clark Publishing Company, 1922.

———. *A Sketch of the Life of Antoine de la Mothe Cadillac, Founder of Detroit.* Detroit, MI: Wilton-Smith Company, 1895.

Burton Historical Collection, Detroit Public Library.

Cangany, Catherine. *Frontier Seaport: Detroit's Transformation into an Atlantic Entrepot.* Chicago: University of Chicago Press, 2014.

Carlisle, Fred. *Chronography of Notable Events in the History of the Northwest Territory and Wayne County.* Detroit, MI: O.S. Gulley, 1890.

Cass, Lewis, to John Armstrong. October 28, 1813. *Excerpts from the Michigan Historic and Pioneer Collections* 40 (1929): 540–42.

Catlin, George. *The Story of Detroit.* Detroit, MI: Evening News Association, 1926.

City of Detroit, Michigan vs. Detroit Citizens Street Railway Company, November 4–5, 1901. Cornell Legal Information Institute. https://www.law.cornell.edu/supremecourt/text/184/368.

Collections and Research Made by the Michigan Pioneer and Historical Society. Vol. 8. Lansing, MI: Wynkoop Hallenbeck Crawford Company, 1907.

Collections and Research Made by the Michigan Pioneer and Historical Society. Vol. 34. Lansing, MI: Wynkoop Hallenbeck Crawford Company, 1905.

Cowan, Walter Greaves, and Jack B. McGuire. *Louisiana Governors: Rulers, Rascals and Reformers.* Jackson: University Press of Mississippi, 2008.

Detroit Free Press Archives. www.freep.newspapers.com.

Detroit Transit History. http://www.detroittransithistory.info.

DetroitYes internet forum. https://www.detroityes.com.

Dunbar, Willis F., and George S. May. *Michigan: A History of the Wolverine State.* Grand Rapids, MI: William B. Edermans Publishing Company, 1955.

Durand, Roger. "Why I'll Drive an Oldsmobile but never a Cadillac OR Louis Durand, Joseph Moreau, and Sieur Antoine Laumet de la Mothe Cadillac." *Journal of the French-Canadian Heritage Society of Michigan* 18, no. 3 (July 1997).

Farmer, Silas. *The History of Detroit and Michigan, or, The Metropolis Illustrated.* Detroit MI: Silas Farmer & Company, 1884.

The French-Canadian Heritage Society of Michigan. http://habitantheritage.org.

Gitlin, Jay. *The Bourgeois Frontier: French Towns, French Traders, and American Expansion.* New Haven, CT: Yale University Press, 2009.

Gitlin, Jay, and S. Heath Ackley. "Freemasons and Speculators: Another Look at the Francophone Merchants of Detroit, 1796 to 1863." *Humanities Research Group Papers* 2 (2003).

Goldstone, Lawrence. *Drive! Henry Ford, George Selden, and the Race to Invent the Auto Age.* New York: Ballantine Books, 2016.

Hervey, John. "Among My Correspondents." *Harness Horse Magazine*, March 2, 1938.

———. "Leaves of Old-time Trotting Politics." *Harness Horse Magazine*, December 1, 1937.

Historic Detroit. www.historicdetroit.org.

Hull, William. *Proclamation to the Inhabitants of Canada*. July 13, 1812. *Excerpts from the Michigan Historic and Pioneer Collections* 40 (1929): 409–11.

Jenks, William. "The First Bank in Michigan." *Michigan History Magazine* 1 (1917).

Kirby, Brendan. *Wicked Mobile*. Charleston, SC: The History Press, 2015.

Kowalski, Greg. *Wicked Hamtramck: Lust, Liquor and Lead*. Charleston, SC: The History Press, 2010.

Laxer, James. "The Capture of Detroit: The Forgotten Battle of the War of 1812." *National Post*, August 16, 2012.

Littlejohn, Edward J. "Slaves, Judge Woodward, and the Supreme Court of the Michigan Territory." *Michigan Bar Journal* (July 2015).

Lodge, John C., and M.M. Quaife. *I Remember Detroit*. Detroit, MI: Wayne State University Press, 1949.

Loomis, Bill. "Before the Motor City: The Horse Age in Detroit." *Detroit News*, November 29, 2014.

———. *Detroit's Delectable Past: Two Centuries of Frog Legs, Pigeon Pie & Drugstore Whiskey*. Charleston, SC: The History Press, 2012.

———. "Living It Up in Old Detroit." *Detroit News*, January 22, 2012.

Maybury, William, to Henry Ford. September 21, 1897. From the William C. Maybury Papers. Burton Historical Collection, Detroit Public Library.

McCracken, Anna. "The Career of Lamothe-Cadillac." Master's thesis, Loyola University, Chicago, 1940.

McGraw, Bill. "Slavery Is Detroit's Big, Bad Secret. Why Don't We Know Anything About It?" *Deadline Detroit*, August 27, 2012.

"Memorial to Congress by Citizens of Michigan Territory." December 10, 1811. *Excerpts from the Michigan Historic and Pioneer Collections* 40 (1929): 346–53.

Miles, Tiya. *The Dawn of Detroit: A Chronicle of Slavery and Freedom in the City of the Straits*. New York: New Press, 2017.

Millspaugh, Arthur Chester. *Party Organization and Machinery in Michigan Since 1890*. Baltimore, MD: Johns Hopkins Press, 1917.

Moran, J. Bell. *The Moran Family: 200 Years in Detroit*. Detroit, MI: Alved, 1949.

New York Times. "Ex-Mayor Bowles of Detroit, Was 73." July 31, 1957.

Palmer, General Friend. "Detroit in 1827 and Later On." *Collections and Research Made by the Michigan Pioneer and Historical Society*. Vol. 35. Lansing, MI: Wynkoop Hallenbeck Crawford Company, 1907.

Paré, George. *The Catholic Church in Detroit, 1701–1888*. Detroit, MI: Gabriel Richard Press, 1951.

Ross, Robert B., and George B. Catlin. *Landmarks of Detroit: A History of the City*. Detroit, MI: Evening News Association, 1898.

Sinacori, Nick. "The Village of Fairview and the Detroit Driving Club." *Motor Cities National Heritage Area*, August 15, 2011.

Szewczyk, Paul. Detroit Urbanism. http://detroiturbanism.blogspot.com.

Voelker, Donald. "Joseph Campau, Detroit's 'Big Shot.'" *Michigan History Magazine* (July/August 1991).

Weekly Register. Vol. 5, September 1813 to March 1814. Baltimore, MD: Franklin Press, 1814.

Woodford, Frank B. *Mr. Jefferson's Disciple: A Life of Augustus Woodward*. Lansing: Michigan State College Press, 1953.

Woodford, Frank B., and Arthur M. Woodford. *All Our Yesterdays: A Brief History of Detroit*. Detroit, MI: Wayne State Press, 1969.

Yanik, Anthony J. *The Fall and Recapture of Detroit in the War of 1812*. Detroit, MI: Wayne State University Press, 2012.

INDEX

ABOUT THE AUTHOR

Mickey Lyons is a Detroit historian and author who specializes in the history of drinking in Detroit, from frontier saloons to Prohibition-era speakeasies to modern-day cocktail bars. Her work can be found in local and national outlets. Her current project, ProhibitionDetroit.com, chronicles Detroit's turbulent and exciting history during Prohibition.

Visit us at
www.historypress.com
..